SYMBOLS
IN ART

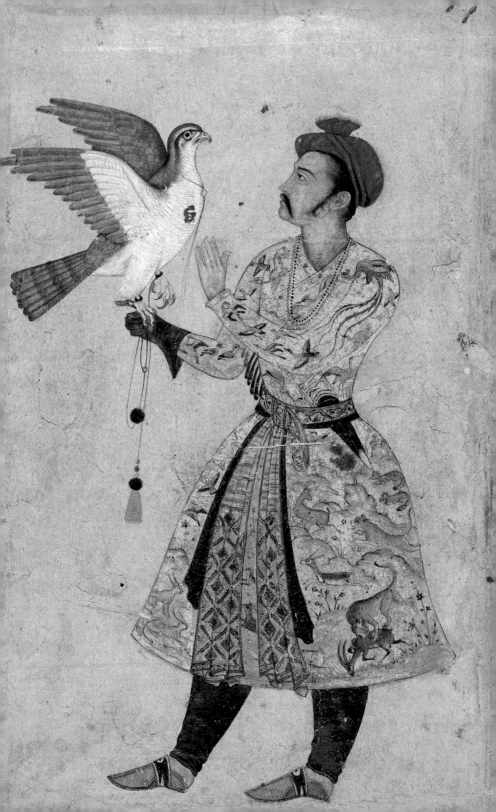

ART ESSENTIALS

SYMBOLS IN ART

—

MATTHEW WILSON

—

CONTENTS

INTRODUCTION

Deciphering the subject matter of works of art falls under the art historical discipline of iconography. This includes the specialism covered by this book: interpreting the language of emblems, motifs and symbols used by artists. A visual symbol is a motif that represents something else, be that a value or a concept. A dog, for example, is often associated with the quality of loyalty and weighing scales with that of justice.

However, the interpretation of symbols is not always a straightforward process. The range of examples presented here includes some symbols that have mutated over time, and others whose original meanings have become blurred. This guide will decode some of the lost or obscured meanings behind symbols, recover their original implications and learn what they can tell us about the artists, cultures and ideologies from which they originated.

It is possible to detect a remarkable degree of international exchange in visual symbols throughout history. A dragon motif originating from China, for example, may be found replicated in medieval Iran; and a palm frond symbol, intended to denote victory over death, can be found on objects from such disparate times and places as Ancient Egypt, the Roman empire and Renaissance Europe, with its emblematic meaning staying the same. These and many other motifs were transported by global networks of trade, the spread of religious beliefs, acts of colonization and the forced interactions of peoples as a result of war. The study of symbols tells us much about unexpected interfaces between world cultures of the past.

Here you will find a selection of the most common symbols found across the world's cultures, chosen to express their power and demonstrate how artists have used them to communicate with an enhanced potency, nuance and depth.

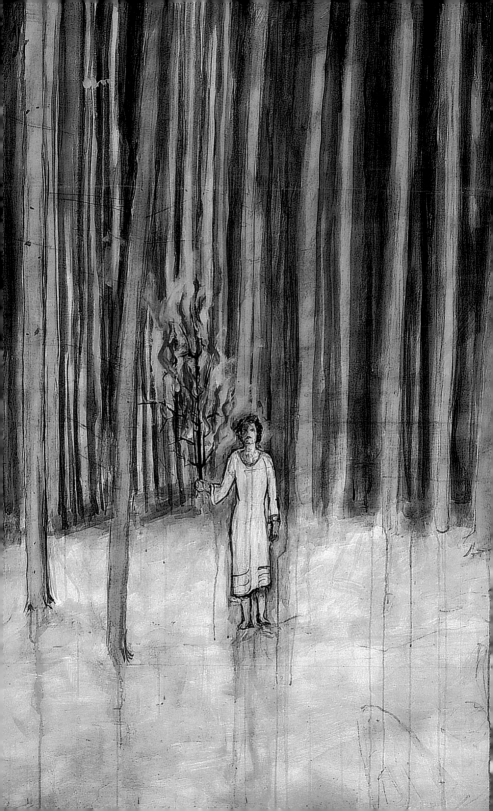

LAND AND SKY

-

**An idea, in the highest sense of that word,
cannot be conveyed but by a symbol**

-

Samuel Taylor Coleridge
1817

WATER

'In it they were born, and with it they lived, and with it they washed away their sins, and with it they died' wrote the Spanish friar Diego Durán in 1581 on the significance of water. The 'they' he is describing are the Aztecs, a people whose indigenous water goddess Chalchiuhtlicue held a central role in their worship and daily life, particularly as a goddess of childbirth and fertility.

These associations are not singular to the Aztecs: water carries similar connotations across world cultures. Hindu, Babylonian and Ancient Egyptian creation myths focus on water as a primordial arena that issued forth life. Christianity and Islam reserve water as a substance of ritual purification. Water is one of four primary elements that were thought to constitute all other materials in the universe in Ancient Greece, and one of five elements in Chinese tradition.

Water has an essential, although initially not-so-obvious, part to play in understanding the 24-ton *Sun Stone*, an object that is thought to have once lain in the Templo Mayor in the Aztec capital of Tenochtitlán (now Mexico City). As with so many other artefacts from Aztec culture, this object was buried – although thankfully not further damaged – by the Spanish conquistadors who arrived in Central America at the beginning of the sixteenth century, and whose arrival augured the demise of the Aztecs. Through pictograms, representations of deities and symbols, the *Sun Stone* is thought to describe the destructive cycles that characterized world history, the yearly calendar, the role of the gods in the fate of mankind and the importance of human sacrifice.

Artist unknown
Sun Stone, reign of Montezuma II (Aztec), 1502–20
Basalt, 358 x 98 cm (141 x 39 in.)
National Museum of Anthropology, Mexico City

The central portion of the stone shows the face of the god Tonatiuh. Surrounding this are four rectangles containing the images of four epochs that were thought to predate the current one. In each one humanity is supposed to have been obliterated by various cataclysms – the final epoch (Four Water) was ended by a global flood and the transformation of all men and women into fish.

Chalchiuhtlicue's head is represented in a stylized form in the rectangle to the lower right of the central face – water is being personified here rather than depicted. Her presence in the *Sun Stone* is part of a symbolic cycle of creation and destruction that reminds us of the wrath of the gods and the elemental power of water to obliterate as well as to rejuvenate.

Water, like other symbols such as the **moon**, **sun** and **fire**, is an elemental phenomenon that possesses a power of the highest order, and therefore carries universal associations to audiences from otherwise disparate cultures. Unlike the smaller-scale symbols taken from flora and fauna such as the **poppy**, **crane** and **shell**, which generally possess meanings that have been nuanced by local custom, water has the greatest kind of emblematic magnitude.

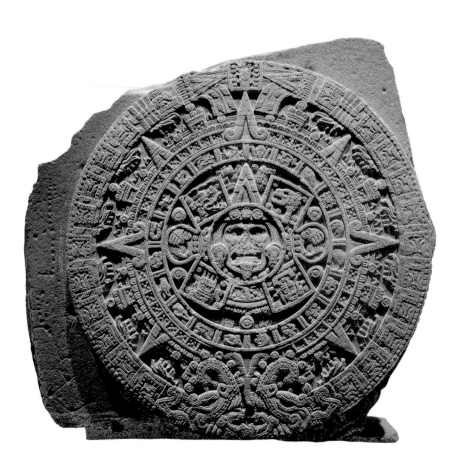

The contemporary video artist Bill Viola uses water alongside such primary symbols as **fire** and **blood** in his work to give it a sense of heightened impact and immediacy. Water in particular had a personal significance to the artist. When he was six years old, Viola had an accident during a fishing trip in upstate New York where he fell into a lake, and he recalls the experience of submersion as a formative one: 'beautiful' and like 'paradise'. His ten-minute video projection, *Tristan's Ascension*, evokes these feelings, showing a waterfall in reverse, with a body rising slowly off a bed and soaring upwards within the column of water. It was first shown in Los Angeles in 2004, as part of a commission that paired Viola's work with a production of Richard Wagner's four-hour opera *Tristan und Isolde*. In the final act, the two central characters tragically die. Viola's *Tristan's Ascension*, and its partner piece *Fire Woman*, symbolize the lovers' demise and dematerialization. Water is being used in way that is consistent with traditional western iconography, making Tristan's transcendence simultaneously a drowning, a baptism and a rebirth.

Bill Viola
*Tristan's Ascension
(The Sound of a Mountain
Under a Waterfall)*, 2005
Video/sound installation
Colour high-definition
video projection, four
channels of sound with
subwoofer (4.1), projected
image size 5.8 x 3.25 m
(19 x 10 ft 8 in.)
Room dimensions
variable, 10:16 minutes
Performer: John Hay

Viola's Video Art often
pairs slow-motion moving
images with archetypical
emblems such as water,
so that modern media is
combined with ancient
symbols. The subject
matter is also linked to
tradition: assumption
scenes are typical in
Christian imagery
where saints and the
Virgin Mary ascend to
heaven after their deaths
(see page 25).

KEY ARTWORKS

Andrea del Verrocchio and Leonardo da Vinci, *The Baptism of Christ*, 1475, Uffizi Gallery, Florence, Italy

Katsushika Hokusai, *Under the Wave off Kanagawa* (Japan), c.1830–32, Metropolitan Museum of Art, New York, NY, USA

J. M. W. Turner, *Snow Storm – Steam-Boat off a Harbour's Mouth*, 1842, Tate, London, UK

Michael Craig-Martin, *An Oak Tree*, 1973, Tate, London, UK

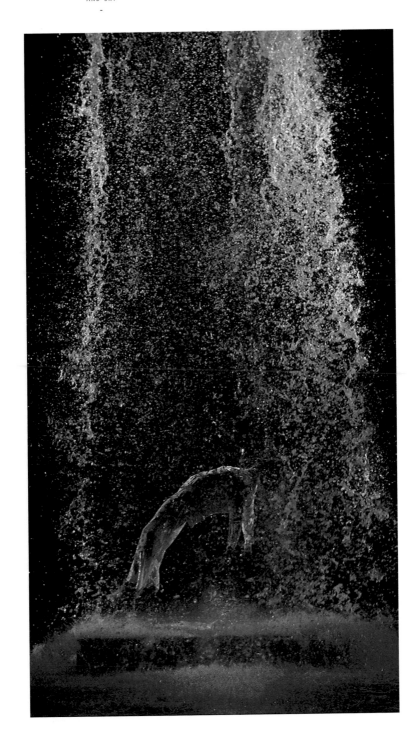

MOUNTAIN

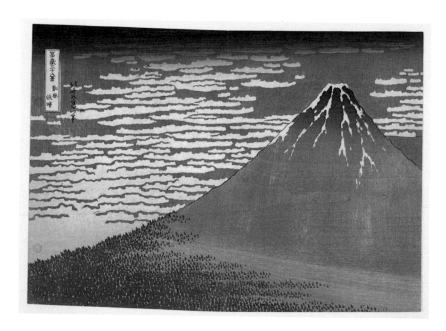

Before the development of powered flight in the twentieth century, no human could ascend closer to the heavens than by standing on the highest mountain. It is therefore no surprise that they have been associated with divinity throughout human history, and have been seen as the dwelling of gods, or as meeting-places between gods and humans. The Navajo, Ancient Greeks, Sumerians, Egyptians and Pre-Columbian Mesoamericans all associated mountains with sanctity. For followers of Daoism, proper mental focus was supposed to be best attained in quiet areas of nature such as mountains. In India Mount Kailash is believed to be the dwelling of the Hindu god Shiva, and the Buddhist Mount Meru, considered to be the centre of the universe, became the inspiration for temple architecture in the form of stupas. In China the first examples of landscapes in art were sculptures of celestial mountains, designed to elevate the owners' minds to a higher spiritual dimension.

Mount Fuji has a colossal national and religious significance in Japan, and in 1830 the seventy-year-old Japanese artist

Katsushika Hokusai
*South Wind, Clear Sky
(or Red Fuji),* from the
series *Thirty-six Views of
Mount Fuji,* c.1830–32
Woodblock print, 24.4 x
35.6 cm (9⅝ x 14 in.)
Metropolitan Museum of
Art, New York

**Heaven and earth are
visually united here: the
altocumulus clouds echo
the striations of the pine
trees below, and the last
vestiges of snow on the
peak resemble forked
lightning descending
from on high.**

Katsushika Hokusai embarked on a project to depict an anthology of thirty-six views of it. The series is an ingenious and highly original undertaking where the mountain is often shown in the context of daily life, operating like a fulcrum around which the normal lives of Japanese citizens rotate. *South Wind, Clear Sky*, however, shows Fuji on its own, and enhances its monumentality by reducing detail to a bare minimum and dominating the scene with the primary tones of blue and red.

Fuji is a volcano whose last eruption was just over a hundred years before Hokusai designed his series *Thirty-six Views of Mount Fuji*. It is a latently hostile presence within its landscape but paradoxically also a life-giving one – the **water** that flows down its distinctly conical sides irrigates the surrounding agricultural land. Many religious groups in Japan venerated Mount Fuji as a site where the spirit world could be accessed, or immortality attained. Pilgrims from Confucian, Shinto and Buddhist sects flocked to the mountain to build shrines, and local legends ascribed many and varied mystical properties to it.

Hokusai himself was a follower of Nichiren Buddhism, which urged its followers to consider the spiritual significance of mundane, earthly actions. This might account for the way he consistently made visual links between the celestial mountain and the business of the real world. This is not unlike the way European artists of the early Renaissance onwards, for example Robert Campin in his *Annunciation Triptych* (*Merode Altarpiece*) on page 45, used objects, plants and animals in mundane settings to call the pious to see divinity all around them. Hokusai's *ukiyo-e* prints of the instantly recognizable Mount Fuji were designed for a wide and diverse audience and could be bought for about the same price as a bowl of noodle soup.

KEY ARTWORKS

Omphalos, Hellenistic period (323–30 BCE), Archaeological
 Museum of Delphi, Delphi, Greece
The Mahabodhi Temple, 7th century CE, Bodh Gaya, Bihar, India
Claude Lorrain, *The Sermon on the Mount*, 1656, Frick Collection,
 New York, NY, USA
Anish Kapoor, *As if to Celebrate, I Discovered a Mountain Blooming
 with Red Flowers*, 1981, Tate, London, UK

CLOUDS

A rain-laden cloud might be seen nowadays as the portent of a spoilt picnic or poor conditions on a motorway journey, but in different times and places the associations have not always been negative. The heavy clouds in Peter Paul Rubens's seventeenth-century painting *Henry IV Receives the Portrait of Maria de' Medici* (page 73), for example, are auspicious since they are saturated with fertilizing **water**, presaging prosperity and growth.

Clouds are often seen in religious imagery alongside such other sacred elements as **angels** and **haloes**. They can act as the throne or vehicle of a deity in both eastern and western religions – for example, the sixteenth-century Japanese sculpture *Deer Bearing a Sacred Mirror of the Five Kasuga Honji-Butsu* (page 86). At other times clouds are symbols of divine concealment, such as in scenes of Jupiter seducing Io from classical mythology, and descriptions of God in the Bible (Psalm 97:2). In Japan Amida, the celestial Buddha, was believed to descend on a cloud to transport a dying person's soul heavenward (although one is not present on the twelfth-century sculpture on page 122), and the motif of a **dragon** coiling between clouds was adopted from Chinese tradition to symbolize the coming of spring rain and the promise of prosperity.

In Sandro Botticelli's *Primavera*, clouds have a subtle but nonetheless pivotal role to play in the overall scheme. On the far left Mercury, the messenger-God in Roman mythology, is prodding some clouds that overlay the orange trees with his caduceus (wand). It is believed that the painting as a whole is an allegorical representation of the coming of spring, and therefore Mercury is dismissing rainclouds ready for summer. However, it has also been suggested that he represents a seeker of knowledge, piercing the skies to allow the light of wisdom to illuminate the grove below. Regardless of its intended significance, Botticelli's original combination of mythological figures and cryptic symbols was certainly conceived to flatter the intellect of his patron – in this case probably a member of the influential Medici family in Florence.

Pages 18–19:
Sandro Botticelli
Primavera (Spring),
1477–82
Tempera on panel,
202 x 314 cm (79½ x 123⅜ in.)
Uffizi Gallery, Florence

In *Primavera*, Venus stands in the middle of the composition. On the right the nymph Chloris is transformed into Flora, the goddess of spring, and on the left are the three Graces. Mercury is mysteriously preoccupied with the clouds above and oblivious to the miraculous events that surround him.

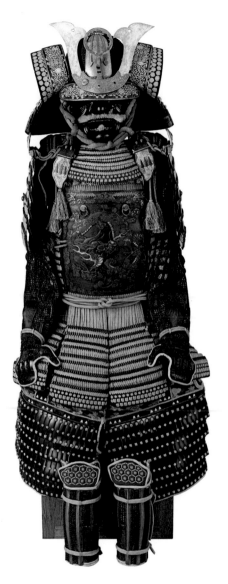

Artist unknown
Armor (Gusoku, Japan),
late 18th–19th century
Iron, lacquer, gold, silver,
copper alloy, leather and
silk, 138.4 x 57.2 x
52.1 cm (54½ x 22½ x
20½ in.)
Metropolitan Museum of
Art, New York

The dragon-among-
clouds motif on Japanese
armour, such as this late
Edo-period example,
carries an innate terror
and majesty, but also
brings good fortune for
the owner.

KEY ARTWORKS

Jar with Dragon (China), early 15th century, Metropolitan Museum
 of Art, New York, NY, USA

Antonio da Correggio, *Jupiter and Io*, 1532–3, Kunsthistorisches
 Museum, Vienna, Austria

Nicholas Hilliard, *Man Clasping a Hand from a Cloud*, 1588,
 Victoria and Albert Museum, London, UK

John Constable, *Study of Clouds*, 1822, Ashmolean Museum,
 Oxford, UK

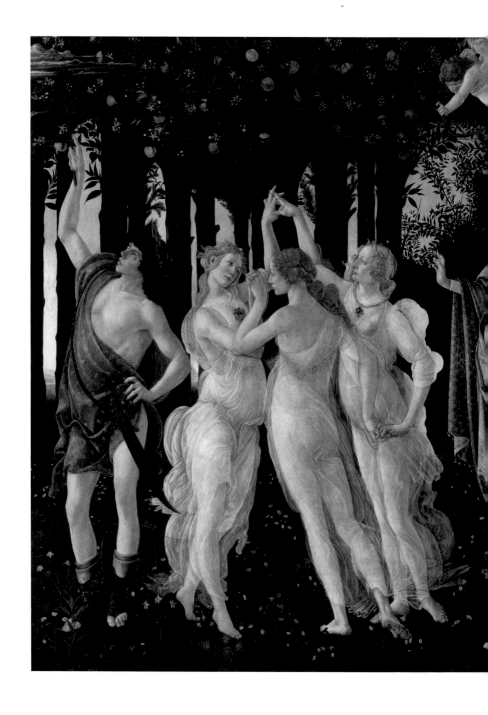

RAINBOW

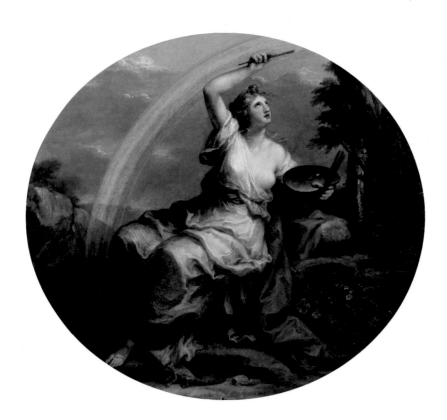

Alongside other symbols that originate from the skies, such as
eagles, **falcons**, **doves**, the **sun** and the **moon**, rainbows often
represent a link between humanity and the gods. Native American
and Nordic myths all feature rainbows in the context of divine
communication, and Jesus is sometimes represented sitting upon
a rainbow (rather than the more customary cloud) in scenes of the
Last Judgement. In the biblical story of the flood, God set a rainbow
in the sky to symbolize his covenant with man after Noah had

reached land, echoing a similar event in the earlier Mesopotamian *Epic of Gilgamesh*. A rainbow is also an attribute of the goddess Iris who was a heavenly messenger in Greco-Roman myth, a female counterpart to Hermes/Mercury who is shown in Sandro Botticelli's *Primavera* (pages 18–19).

In Angelica Kauffman's painting the female figure is dressed and posed similarly to Iris, but she is actually intended to be a personification of Colour. It was one of four aspects of art that were painted by Kauffman for the Royal Academy's Council Chambers in the Strand, London, alongside *Design*, *Invention* and *Composition*. The female allegory in *Colour* dips her brush into a rainbow to transfer hues from the heavens to her palette. The three primary colours were also deliberately incorporated into the scene: she is dressed in yellow and red and sits in front of a blue sky. As one of only two female founding members of the Royal Academy, Kauffman's depiction of active, heroic female allegories for the four elements of art carried an added resonance.

Rainbows have further meanings in different contexts. They are rare occurrences, and as such are often linked with good fortune and prosperity, for example, in Dahomey culture in West Africa, or in China, with auspicious events such as marriage. In a rainbow all the colours are united, and as such they have also been used in emblems that celebrate harmony such as the flags of peace and the LGBTQ movement.

Angelica Kauffman
Colour, 1778–80
Oil on canvas,
126 x 148.5 x 2.5 cm
(49⅝ x 58½ x 1 in.)
Royal Academy, London

A chameleon is sitting beneath the personification of Colour as a companion in colour production.

KEY ARTWORKS

Adriaen Pietersz van de Venne, *Fishing for Souls*, 1614, Rijksmuseum, Amsterdam, Netherlands

Peter Paul Rubens, *The Rainbow Landscape*, c.1636, Wallace Collection, London, UK

Joseph Wright of Derby, *Landscape with a Rainbow*, 1794, Derby Museum and Art Gallery, Derby, UK

Wassily Kandinsky, *Cossacks*, 1910–11, Tate, Liverpool, UK

Norman Adams, *Rainbow Painting (I)*, 1966, Tate, London, UK

LIGHTNING

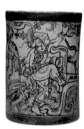 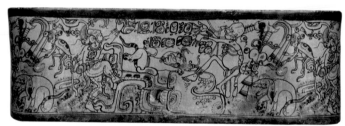

In contrast to the generally propitious and serene significance of **clouds** and **rainbows**, it is a common trope across world religions to show thunderbolts as weapons of divine punishment or revelation. For example, a thunderbolt is the attribute of Zeus/Jupiter and the Hindu god Indra; in Buddhism and Hinduism a stylized thunderbolt called a *vajra* represents spiritual power to create and destroy.

Lightning is not depicted on the Mayan *Mythological Vessel*, but it is symbolized by an axe in the right hand of Chahk, the rain god, who takes centre stage in this riotously decorated drinking cup produced in the region now known as Guatemala. The lightning axe is of paramount importance to this scene, which describes the life-generating and destructive capacities of **water**. It is with this axe that Chahk will strike the sky and disgorge rain upon the land.

He is caught in the middle of what looks like a dance, with one foot off the ground, holding an animate stone in his left hand. There is no consensus on the true meaning of the scene but Chahk may be recoiling his axe in order to swing it in a wide arc down onto the body of the Baby Jaguar (a Mayan deity) who lies prone ahead of him. Baby Jaguar rests upon a large, deformed beast that likely

Artist unknown
Mythological Vessel
(Maya), 7th–8th century
Ceramic, 14 x 11.4 cm
(4½ x 5 in.)
Metropolitan Museum of
Art, New York

**The feet of the Mayan
rain god Chahk are
being splashed by
vomit cascading from
the mountain's jaws to
signify the putrefaction
that results from
waterlogging.**

represents the spirit of a **mountain**. Behind them a god of death dances in response to Chahk, holding hands aloft, maybe to receive Baby Jaguar's spirit after his execution. An alternative interpretation suggests that the dance being performed by Chahk and the god of death is magically bringing Baby Jaguar into existence, delivering him out from the realm of death into the land of the living. Either way the scene has the same overarching message about the power of lightning: after Chahk smashes his axe into the skies and unleashes rain, fertility and the renewal of life ensue.

Walter De Maria's *The Lightning Field* is an example of twentieth-century land art and occupies a vast terrain on the high plateaus of New Mexico. Its 400 stainless steel poles, arranged in a grid over an area of 1 mile x 1 km were designed to attract lightning strikes. However, because lightning has to fall within 61 metres (200 ft) of the installation to make contact with it, they strike only about sixty times a year, normally in late summer or early autumn.

KEY ARTWORKS

Giorgione, *The Tempest*, c.1507, Accademia, Venice, Italy

Francisque Millet, *Mountain Landscape with Lightning*, c.1675, National Gallery, London, UK

William Blake, *The Great Red Dragon and the Woman Clothed with the Sun*, c.1805, National Gallery, Washington, DC, USA

Gokoshima (Five-Pronged Vajra), 12th–14th century, Brooklyn Museum, New York, NY, USA

Walter De Maria
The Lightning Field, 1977
400 stainless steel poles,
1 mile x 1 km
Long-term installation,
Western New Mexico

This sculpture reconnects us with a primeval sense of wonder and our smallness in the face of the raw power of nature. It resets our sense of scale in the order of the cosmos.

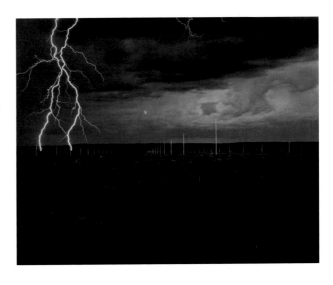

MOON

Lightning bolts and the sun are symbols generally associated with
the divine power of masculine gods. By contrast, in Greco-Roman,
Chinese, Celtic and Egyptian religions, the moon is linked with
female deities. The moon is also associated with female figures in
Christianity: in Chapter 12 of the New Testament's apocalyptic
Book of Revelation, a woman is mentioned: 'clothed with the sun,
and the moon under her feet, and upon her head a crown of twelve
stars.' This description was adopted by artists representing Mary
in scenes depicting the Immaculate Conception, and thus a moon
became part of the iconography of the Virgin Mary.

A crescent moon as a symbol of the Virgin's chastity was
adopted by the city of Constantinople when it was in Christian
hands, but it was appropriated by the Arab armies who occupied the
city in the fifteenth century, and thereafter became an emblem of
the Ottoman empire.

In mythologies from around the world, the moon is often
connected with insanity and lack of reason, and its power over tidal
patterns. In China the moon is a female, 'yin' force and is associated
with hares. On imperial robes, the moon is an auspicious symbol,
and in the robe on page 28 the moon is depicted on the right
shoulder with a hare in the middle.

The sumptuous *Mary Queen of Heaven* was painted for a
convent near Burgos in Spain by a Netherlandish artist. In it
Mary is ascending to heaven with Jesus, God and the Holy Spirit
(symbolized by a dove) waiting to crown her as the queen of
paradise. It is a scene intended to focus the mind of its audience
on the glories of the afterlife through its display of sumptuous
fabrics and the heavenly choir. Equally important is the panoply
of recognizable symbols, not least Mary's shimmering gilded
crescent moon at the base of the composition, which functions
as her celestial transport.

Artist of the Lucy Legend
Mary Queen of Heaven,
1485–1500
Oil on panel,
199.2 x 161.8 cm
(79 x 64 in.)
National Gallery,
Washington, DC

**The yellow crescent moon
on which Mary stands is
a symbol of chastity in
Christian iconography.**

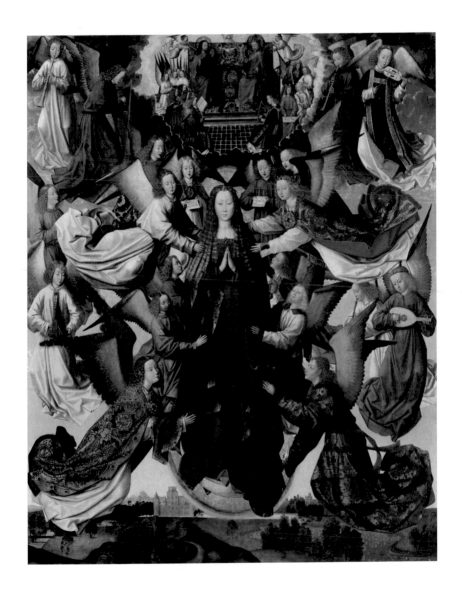

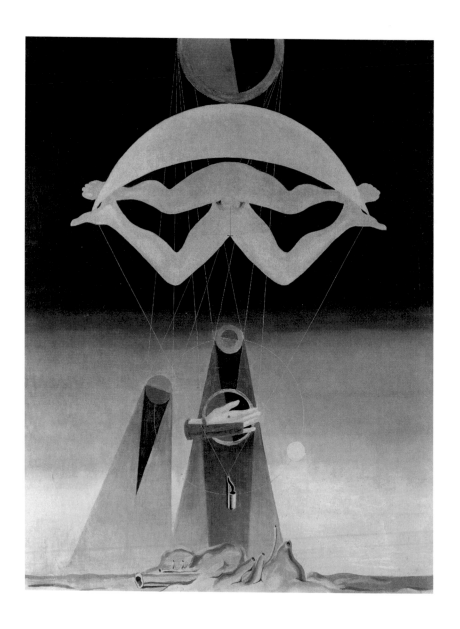

Max Ernst
Men Shall Know Nothing of This, 1923
Oil on canvas,
80.3 x 63.8 cm
(31⅝ x 25⅛ in.)
Tate, London

Ernst wrote an enigmatic poem on the reverse of the painting that links it to Sigmund Freud's patient Daniel Paul Schreber who fantasized about being turned into a woman. In the painting, the adjacent sun and moon symbolize the meeting of male and female principles.

An inverted crescent moon appears at the top of the composition in Max Ernst's Surrealist *Men Shall Know Nothing of This*, painted in Paris in 1923. The moon and other elements of the painting obey an altogether more cryptic system of iconography, probably based on psychoanalysis and alchemy rather than Christian symbolism. A large sun-like circle at the top of the image is touching the moon, below which are a copulating couple, depicted as a set of disembodied legs. Below this is another set of circles that resembles a diagram of planetary orbits, with the light of the sun casting shadows on the desert below.

This combination of symbols has led art historians to see it as a reference to Sigmund Freud's early twentieth-century case study of Daniel Paul Schreber, an ex-High Court judge who had a fantasy about being turned into a woman who would be fertilized by God to produce a new race of mankind. Freud recorded his patient's fascination with the sun and his fear of dismemberment, as well as his own belief that Schreber feared castration and suffered from paranoid schizophrenia. This is symbolized by the conjoining of sun-man and moon-woman, and the disembodied phallic objects on the desert floor. The alchemical symbols include the copulating couple, which signified the meeting of opposites, and the inverted crescent moon, a symbol of an eclipse. Esoteric knowledge and Freudian analysis were a source of fascination to Ernst (a one-time student of psychology) and his Surrealist colleague André Breton (who had trained as a psychoanalyst) in the 1920s.

KEY ARTWORKS

Francisco de Goya, *Witches' Sabbath*, 1798, Lázaro Galdiano Museum, Madrid, Spain

Tsukioka Yoshitoshi, *Chang E Flees to the Moon* from *One Hundred Aspects of the Moon* (Japan), 1885, British Museum, London, UK

Evelyn De Morgan, *Helen of Troy*, 1898, Wightwick Manor, Wolverhampton, UK

Henri Rousseau, *The Dream*, 1911, Museum of Modern Art (MoMA), New York, NY, USA

SUN

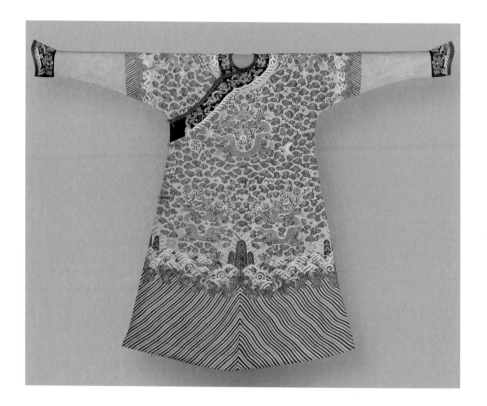

Artist unknown
*Emperor's Dragon Robe
(Mang Pao)*, c.1840
Silk slit tapestry weave
(*kesi*), centre back length
154.9 cm (61 in.)
Philadelphia Museum
of Art, Philadelphia

This dragon robe is
filled with auspicious
symbols to celebrate the
emperor's authority and
magnificence. One of the
most important is a red
sun emblem on the robe's
left shoulder, not visible
here but enlarged on the
next page.

Detail from
Emperor's Dragon Robe
(Mang Pao), c.1840

**The sun is represented
here by a red sphere
that contains a three-
legged bird.**

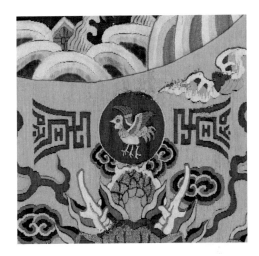

Across world cultures the sun is frequently used as a symbol of
the mightiest of virtues. It is an attribute of the allegory of Truth
in Renaissance art, and solar deities feature in innumerable myths
from Babylonian, Egyptian, Celtic, Greek, Indian, Cherokee and
Mayan civilizations.

There is a sun motif on the left shoulder of the Chinese
emperor's *Dragon Robe* and it is also a symbol of unimpeachable
authority, this time for a temporal ruler. In China a sun motif
represented masculinity and an active 'yang' force, as opposed to
the female and passive ('yin') **moon**, which was an emblem of the
empress. Overall this robe symbolized the emperor's noble qualities
in 'Twelve Ornaments' (sun, **moon**, stars, **dragons**, the symbol 'fu'
meaning good fortune, axe, water weeds, goblets, pheasant, **fire**,
mountain and rice), each of which denoted a particular virtue
according to Confucian beliefs. On the front of the garment are
the stars (beneath the collar), **dragons**, the 'fu' symbol and axe (just
below the chest on left and right), water weeds and a goblet (on the
left and right of the bottom of the yellow section). The back of the
garment features the other symbols. Within the imperial court only
the emperor was allowed to bear all of them together on his robes,
and even the bright yellow colour was reserved solely for his use.

The positioning of the emblems on the robe is also significant:
the celestial sun, **moon** and stars are nearest the head, and the
lesser symbols are at lower points. When it is worn by the emperor,
therefore, he literally embodies the cosmos, and his head is located
at the point closest to heaven. The lesser ranks of the Chinese court
wore clothing that bore lesser emblems so as to distinguish them

from their superiors. Here we have a good example of how uniforms are components of the successful functioning of power, and how the symbolism of colour, material and shape allow the members of social groups to judge one another's status in the hierarchy.

The sun emblem of the Chinese emperor was adopted in Japan, and the power of this symbolism has carried through to the present day – their national flag still features a rising sun.

An example of sun symbolism surviving into the twenty-first century is *The weather project* by Olafur Eliasson – a colossal installation commissioned by Tate Modern in London. By placing this replica setting sun in what was previously the Bankside Power Station's turbine hall, he emphasizes its role as an exploitable energy source.

Olafur Eliasson
The weather project, 2003
Monofrequency lights, projection foil, haze machines, mirror foil, aluminium and scaffolding, 26.7 m x 22.3 m x 155.4 m (87 x 73 x 509 ft)
Temporary site-specific installation in the Turbine Hall, Tate Modern, London

This is also arguably a sun for the anthropocene age: confined, reduced in scale and stature, and dethroned from its prior eminence.

KEY ARTWORKS

The Sun God Tablet, Temple of Shamash, Sippar, Babylon,
 860–850 BCE, British Museum, London, UK
Michelangelo, *The Creation of the Sun and Moon*, 1511, Sistine
 Chapel, Vatican City, Rome, Italy
Claude Monet, *Impression, Sunrise*, 1872, Musée Marmottan
 Monet, Paris, France
Nancy Holt, *Sun Tunnels*, 1973–6, Great Basin Desert, UT, USA

-
LAND
AND SKY
-

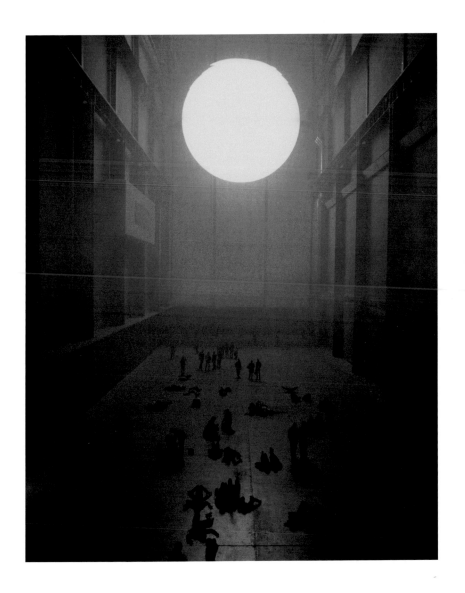

FIRE

In the substances feature in this section, fire is the only one that can be created and controlled by humans, but it is nonetheless portrayed in many global cultures as sacred and capable of purification, sacrifice and religious enlightenment. The symbolism of fire is of highest importance, for example, to the Smithsonian's *Shiva Nataraja* (*Shiva, the Lord of the Dance*) as a statement on the cosmic authority of this deity, one of the three most important gods in the Hindu pantheon.

In his furthest left hand, Shiva is holding *agni*, a three-pronged flame that represents the fire that he will use to destroy the universe. In his furthest right hand, however, he holds a *damaru*, a drum whose tempo will generate the cosmos back into existence. The entire figure is also encircled by a hoop (similar to an aureole or **halo**) emitting flames that symbolize the cosmic Armageddon-through-fire. It is through these visual signs that Shiva's role as a destroyer/creator – and the conception of time as a never-ending sequence of births and deaths – can be understood.

The demon under his feet represents ignorance, trampled on during Shiva's *ananda tandava* (dance of bliss). A standardized iconography for Shiva Nataraja – of which this is a magnificent example – came into existence in about the fifth century CE, and was perfected under the rule of the Chola dynasty. The Cholas were a family that exerted power through southern India, Sri Lanka, the Maldives and other regions in South-East Asia. The promotion of this energetic and graceful image, with Shiva striking a dynamic yet equipoised dance move with his dreadlocks spraying outwards, may have been endorsed by the Cholas. It shares in the dynasty's spirit of triumph over conquered people and may have even reflected specific ritual dances of Chola warriors.

Artist unknown
Shiva Nataraja (India),
c.990
Bronze, 70.8 x 53.3 x
24.6 cm (27⅞ x 21 x
9⅝ in.)
Smithsonian, Washington,
DC

Shiva is one of the three principal Hindu deities, the others being Vishnu and Brahma. Shiva is depicted in several distinct roles, but as Nataraja (Lord of the Dance), he embodies the cyclical energy of the universe: he destroys it with fire before regenerating it again.

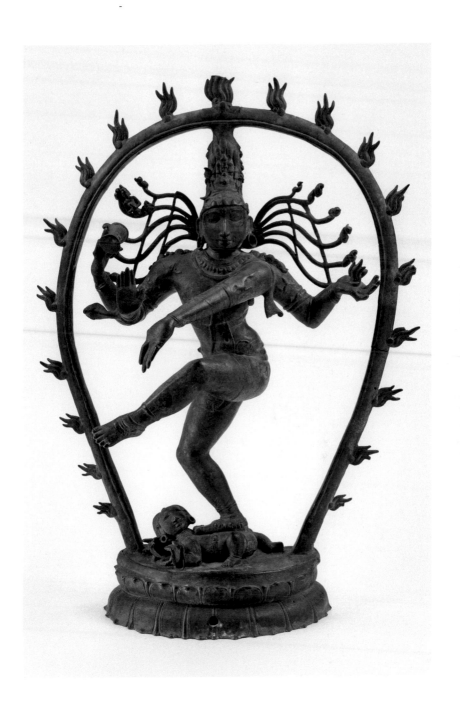

The idea that fire can destroy, purify and regenerate is also present in a work of art created about a millennium later by the German artist Anselm Kiefer: *Mann im Wald* (*Man in the Forest*). This, as with many works of art by Kiefer, is engaged with Germany's identity and how its occupants have processed the legacy of the Second World War.

Mann im Wald shows a long-haired, moustachioed figure who resembles the artist himself, in a pine forest holding a flaming branch and surrounded by a rippling white aura, rather like *Shiva Nataraja*. The woodland location is not specified in Kiefer's title but in other similar paintings he refers to the Teutoburg Forest, and this may be the setting alluded to in this image. This was a very significant woodland in Germany's history and national consciousness as it was where German tribes inflicted a defeat on their Roman invaders in 9 CE. The Roman historian Tacitus recorded that captured Romans were burnt by their enemy as sacrifices. However, the overall meaning of the painting and its symbols is not without ambiguity. It is possible that Kiefer is presenting himself as a purifier of the toxic history of Germany, fire becoming a personal symbol for a revitalized national identity.

Anselm Kiefer
Mann im Wald (*Man in the Forest*), 1971
Acrylic on nettle,
174 x 189 cm
(68½ x 74⅜ in.)
Private collection,
San Francisco

It is possible that Kiefer is representing a kind of modern-day prophet, drawing on flame imagery in Hebrew accounts of the burning bush or biblical descriptions of pentecostal fire.

KEY ARTWORKS

Huehueteotl, God of Fire (Mixtec), Pyramid of the Sun, Teotihuacan, 600–900 CE, National Museum of Anthropology, Mexico City, Mexico

Giotto di Bondone and workshop, *Pentecost*, c.1310–18, National Gallery, London, UK

Peter Paul Rubens, *Prometheus Bound*, 1612, Philadelphia Museum of Art, PA, USA

K Foundation (Jimmy Cauty and Bill Drummond), *K Foundation Burn a Million Quid*, 1994, Isle of Jura, Scotland, UK

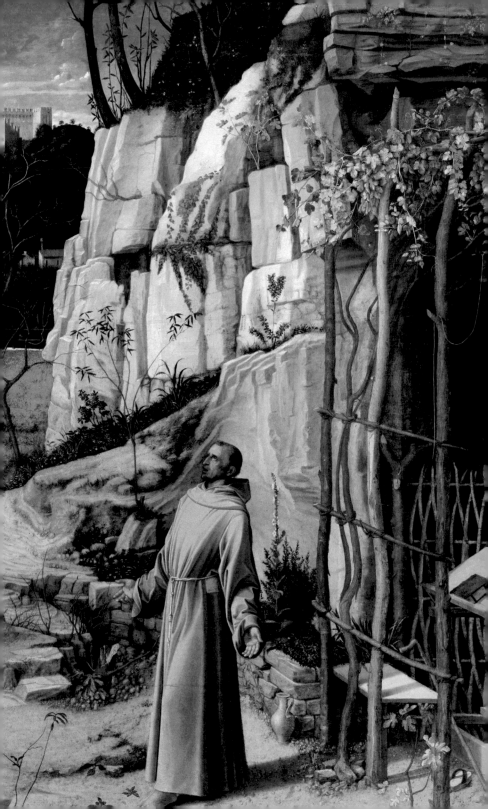

PLANTS

-

**The greater and more thoughtful the artists,
the more they delight in symbolism, and the
more fearlessly they employ it**

-

John Ruskin
1856

CARNATION

Even though they are easy to miss on first glance, the crossed
pair of pink carnations on the white square at the bottom left-
hand corner of *The Graham Children* hold an important key for its
meaning. Like many other plants in this book, including the **poppy**,
palm and **laurel**, the carnation is not particularly rare, but over time
various meanings have been attributed to it. Artists have exploited
these to add detail and complexity to their artworks.

Generally speaking a carnation represents betrothal, in both
European and Asian art; in China the carnation is typically
associated with marriage, and often paired with a **lily** and a
butterfly. It is also a flower often associated with the Virgin Mary,
as carnations were said to have grown on the ground where Mary's
tears fell after the crucifixion, and pink carnations therefore stand
for maternal or compassionate love.

Hogarth's *The Graham Children* encapsulates four stages of
childhood, and the informal atmosphere of a well-to-do eighteenth-
century London household. These are the children of Daniel
Graham, apothecary to King George II, presented by Hogarth to
celebrate carefree youth on the one hand, and suggest their adult
destinies on the other. Thomas, the youngest member of the family,
sits on an elaborate gold-painted pull-cart, eating a rusk. Henrietta,
the eldest child, guides her brother with a maternal hand and fixes
the viewer with her gaze. Next to her Anna Maria curtseys like a
debutante, but her brother Richard is caught in the middle of some
fun – exciting his pet goldfinch with the mechanical song produced
from his bird organ. Unbeknown to him, the bird is actually being
riled by a cat who has just hopped up the back of Richard's chair.

But what's more interesting than the figures and their actions
in this painting is its unusually prolific use of symbols to articulate
a message not apparent at first glance. Carnations lie beneath
Thomas and Henrietta. She is dressed in blue, just as Mary is
conventionally shown, and she holds cherries, the fruit of paradise,
which are sometimes shown in the hands of the Infant Christ. Even
the goldfinch in the cage can also be read on a symbolic level as

**Detail from William
Hogarth**
*The Graham
Children*, 1742

**Before Hogarth had
finished the painting,
Thomas Graham, the
boy on the far left, had
died at the age of two.
The delicately rendered
carnations on the floor
are arguably the most
subtle and affecting
symbol of sacrifice
and personal loss in
the painting.**

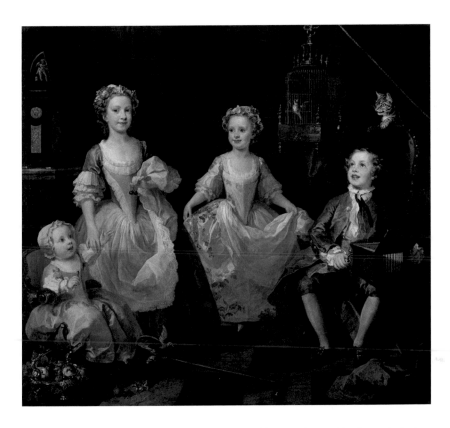

William Hogarth
*The Graham
Children*, 1742
Oil on canvas, 160.5 x
181 cm (63¼ x 71⅜ in.)
National Gallery, London

**The scythe and hourglass
on top of the timepiece
reinforce the allegorical
subtext of the painting.
The ripe apples, pears
and grapes in the basket
in the foreground allude
to the boy's youth, and
the cat scaring the bird
in its cage also suggests
persistent threats, such
as infant mortality in
Britain in the eighteenth
century.**

it is often depicted alongside Christ, and was said to have plucked a thorn from Jesus' crown before His crucifixion. The red on its plumage was thought to be a spot of His blood. Although we have no direct testimony from the artist, it seems likely that Hogarth deliberately sowed symbolic references to Christ's martyrdom to indicate the poignant early death of two-year-old Thomas Graham, who died before the painting was completed.

KEY ARTWORKS

Leonardo da Vinci, *Madonna of the Carnation*, 1478–80, Alte
 Pinakothek, Munich, Germany
Andrea Solario, *A Man with a Pink*, c.1495, National Gallery,
 London, UK
Francisco de Goya, *The Marquesa de Pontejos*, c.1786, National
 Gallery of Art, Washington, DC, USA
John Singer Sargent, *Carnation, Lily, Lily, Rose*, 1885–6, Tate,
 London, UK

CYPRESS

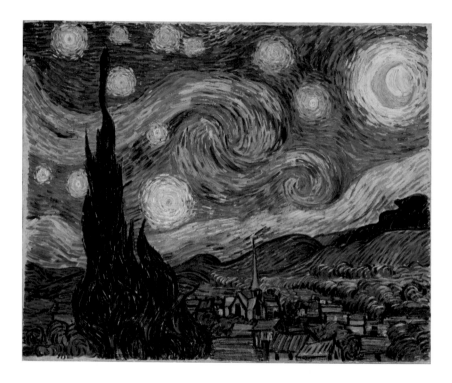

'The cypresses are always occupying my thoughts, I should like to make something of them like the canvases of the sunflowers . . . It is as beautiful of line and proportion as an Egyptian obelisk. And the green has a quality of such distinction . . . it is a splash of *black* in a sunny landscape.' This excerpt from Vincent van Gogh's letter to his brother in 1889 sheds some light on what cypresses meant to him, no doubt influenced by his mental state after a series of breakdowns the previous year. For Van Gogh the cypress (as much as the olive grove) was a distinctive emblem of the French region of Provence, where the artist had settled. But his words also show that he was aware of their historical associations.

In Ancient Greece and Rome, as well as in China and the Indian subcontinent, cypresses signified longevity and even immortality, as they were evergreen. Curiously they are also associated with death, much like **poppies**, and it has therefore become traditional to

Vincent van Gogh
Starry Night, 1889
Oil on canvas, 73.7
x 92.1 cm (29 x 36¼ in)
Museum of Modern Art
(MoMA), New York

In *Starry Night* the looming cypress in the foreground might stand either as a cenotaph or as a symbol of eternity that connects earth and heaven: beautiful, proportionate and a black stain on the Provençal countryside.

plant them in cemeteries. The cypress supposedly has the power to preserve bodies.

Cypresses have a specific religious significance in Japan: their scented wood is used in the construction of Buddhist temples and Shinto shrines, and cypress branches are also ritually burned in Shinto ceremonies. Kanō Eitoku's cypress, painted in the sixteenth century, seems like Van Gogh's to be infused with a spiritual inner energy as it reaches into the sky, wrestling the surrounding landscape with its trunk and branches.

Van Gogh was fascinated by Japanese culture, but it is unlikely that he would have been familiar with Eitoku's painting. Unlike *Starry Night*, *Cypress Trees Screen* was a functional piece of furniture – a sliding screen door (*fusuma*) – whose extensive use of gold leaf makes it valuable in monetary as much as aesthetic terms. It was commissioned by the powerful feudal warlord Toyotomi Hideyoshi for the noble Hachijōnomiya family, for whom this vigorous and holy tree would be a suitably dignified emblem.

Kanō Eitoku
Cypress Trees Screen,
16th century
Ink on paper covered
with gold leaf, 170.3 x
460.5 cm (67 x 181¼ in.)
Tokyo National Museum,
Tokyo

**Whereas Van Gogh
used the cypress tree to
embody his own inner
feelings, Eitoku's tree is
a flattering symbol for
his patron: it possessed
religious power and
Eitoku has been clear
in showing how it has
asserted itself within its
environment.**

KEY ARTWORKS

Jan Weenix, *Gamepiece with a Dead Heron*, 1695, Metropolitan
 Museum of Art, New York, NY, USA

Hubert Robert, *Cypresses*, 1773, State Hermitage Museum,
 St Petersburg, Russia

Katsushika Hokusai, *Mishima Pass in Kai Province*, from the series
 Thirty-six Views of Mount Fuji (Japan), c.1830–32, Metropolitan
 Museum of Art, New York, NY, USA

Arnold Böcklin, *The Isle of the Dead*, 1880, Kunstmuseum Basel,
 Basel, Switzerland

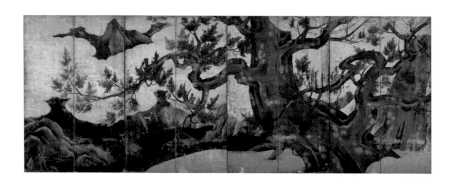

LAUREL

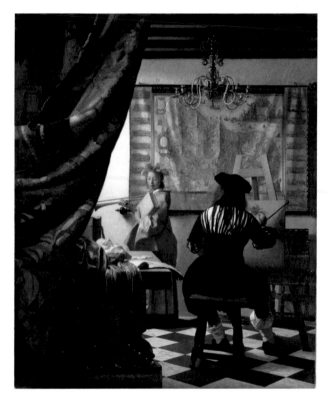

The term 'laureate', as in Poet Laureate or Nobel Laureate, derives from the laurel bush, which was associated with honour, excellence and victory in the arts and in military combat. In Greco-Roman mythology it was connected with Apollo. He worshipped the plant after Daphne, the virginal nymph with whom he had fallen in love, metamorphosed into a laurel tree to thwart his lustful grasps. Victors in athletic, poetry and music competitions in Ancient Greece were crowned with a laurel wreath, and in Roman art the victors in military campaigns were decked with laurel crowns and **palm** fronds.

In Vermeer's *The Art of Painting* – painted in the Dutch city of Delft – the female figure in blue is Clio, the muse of history.

Johannes Vermeer
The Art of Painting, 1666
Oil on canvas,
120 x 100 cm
(47 x 39 in.)
Kunsthistorisches
Museum, Vienna

**Vermeer draws our eye
to the laurel crown by
positioning Clio's head
in the central portion
of the composition at
the intersection of the
horizontal and vertical
borderlines on the map.**

Her role as a celebrator of great events is evident in her attributes: a **trumpet** of pronouncement, a book of knowledge and a laurel crown. The artist, whose back is turned to us, is caught in the moment of painting the latter and most important of these possessions, perhaps to celebrate the art of painting as a supreme profession, equal in worth to poetry or philosophy.

The laurel branch on the left of the reverse of Leonardo's *Ginevra de' Benci* is mirrored by a **palm** on the right, encircling a sprig of juniper. Each plant has an allegorical meaning: the juniper (*ginepro* in Italian) is a pun on the name Ginevra, the laurel symbolizes the sitter's poetic abilities, and the **palm** probably refers to virtue (see pages 50–51). As if to clarify the symbolism beyond doubt Leonardo added the motto *Virtutem Forma Decorat* ('beauty adorns virtue'). This arrangement of symbols also formed the personal emblem of Bernardo Bembo, the Venetian ambassador to Florence, and as such the portrait is thought to be a celebration of friendship between Bembo and de' Benci.

Leonardo da Vinci
Ginevra de' Benci, 1474–8
Oil on panel,
38.1 x 37 cm
(15 × 14½ in.)
National Gallery,
Washington, DC

The reverse of Leonardo's
***Ginevra de' Benci* (left)**
contains a symbolic
portrait of the sitter
to complement the
figurative one on
the front.

KEY ARTWORKS

Ara Pacis Augustae (Altar of Augustan Peace), 9 BCE, Ara Pacis Museum, Rome, Italy

Paolo Veronese, *The Choice between Virtue and Vice*, c.1565, Frick Collection, New York, NY, USA

Gian Lorenzo Bernini, *Apollo and Daphne*, 1622–5, Galleria Borghese, Rome, Italy

Antonio Canova, *Apollo Crowning Himself*, 1781–2, The J. Paul Getty Museum, Los Angeles, CA, USA

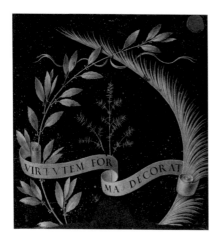

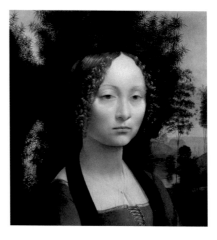

LILY

Lilium candidum – the most repeatedly used lily species in western visual culture – possesses a striking whiteness that complements its serene flower shape and overall height. These qualities were frequently linked to the virtues of virginity and purity in Mediterranean civilizations. *Lilium candidum* are thought to have originated in Palestine and Lebanon, at the eastern edge of the Mediterranean, but mythology accounts for their appearance in more imaginative ways. According to Greco-Roman mythology, when Hera/Juno, the queen of the Olympian gods, was breastfeeding her stepson Herakles/Hercules, her milk was so profuse that when the infant moved away, the overflow sprayed to the earth and sky. The Milky Way was formed where it landed in the heavens, and where the milk fell on the land lilies grew. The association of lilies with divine purity and maternity is also present in Hebrew teaching as well as Christian symbolism. In biblical art the lily is frequently depicted as an attribute of Virgin Mary (alongside such other symbols as the **moon**) and most often in scenes of the Annunciation.

Hence a vase of lilies sits at the very centre of the *Merode Altarpiece*, also known as the *Annunciation Triptych*. It shows an event of huge significance to Christians – the announcement by the **Angel** Gabriel that Mary, a mortal woman, would give birth to the Messiah. The setting, which shows a humdrum Netherlandish

Robert Campin
Merode Altarpiece
(central and left-hand panel), 1427–32
Tempera and oil on panel, 64.1 x 117.8 cm
(25¼ x 46⅜ in.)
Metropolitan Museum of Art, New York

The whiteness of the lily represents the Virgin Mary's purity. It is often represented in scenes of the Annunciation – sometimes in a vase as in this painting or held by the Angel Gabriel.

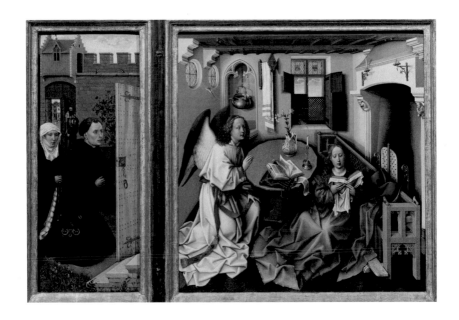

courtyard and interior, appears undistinguished. In fact, it is teeming with symbolic details masquerading as everyday objects such as the lilies, the candle and the bronze basin hanging in the upper left-hand corner. This gives us an insight into the medieval European mind, which regarded each earthly object as a potential source of divine meaning whose significance could be decipherable to the pious and the curious. It tells us about their ardour to witness the mystic bursting forth from the base material of daily life.

KEY ARTWORKS

Simone Martini, *Annunciation*, 1333, Uffizi Gallery, Florence, Italy

Francisco de Zurbarán, *The House in Nazareth*, c.1640, Cleveland Museum of Art, Cleveland, OH, USA

Sir Stanley Spencer, *The Resurrection, Cookham*, 1924–7, Tate, London, UK

David Hockney, *Mr and Mrs Clark and Percy*, 1970–71, Tate, London, UK

LOTUS

The lotus is a symbol of spiritual purity across innumerable global cultures, and is probably the most exalted and well used of all the plant symbols in this book. Its biological features account for its pervasive success as a symbol: a lotus's roots rise from the stagnant mud of a riverbed. The petals and the flower (which opens in the morning and closes at night) sit serenely on top of the water surface. Thus it signifies beauty emerging from chaos and the interaction of mortal earth with the divine **sun**.

The lotus is of great importance to Hinduism as a symbol of perfection and divine birth: Brahma is said to have been born out of a golden lotus, and the flower is the attribute of many deities including Vishnu, Surya, Padmapani, Lakshmi, Parvati, Saraswati and Skanda. In Buddhism the lotus is also synonymous with immaculacy, but it carries an even more fundamental and spiritual quality as it embodies the enlightenment pursued by Buddha. Statues of the Buddha frequently show him seated upon a lotus throne, and the lotus is also one of the eight lucky emblems shown on the Buddha's **foot**.

The symbol of the region of Upper Egypt is a lotus and several Egyptian deities are associated with the lotus, including Nefertem, who was thought to have been born out of one: an immaculate birth from the turmoil of the primordial waters. The *Head of Nefertem* is actually a portrait of Pharaoh Tutankhamen (c.1341–c.1323 BCE) in the guise of Nefertem, at the moment of his lotus-birth. This conjoining of the regal and the celestial was intended to link Tutankhamen with solar authority and articulate the regenerative power of the Egyptian gods. Here the lotus has been harnessed as a symbol of worldly authority.

Artist unknown
Head of Nefertem
(Egypt), New Kingdom,
18th Dynasty
Wood, stucco and paint,
height 30 cm (11⅞ in.)
Egyptian Museum, Cairo

**The lotus was a symbol
of royal power in
Ancient Eygpt.**

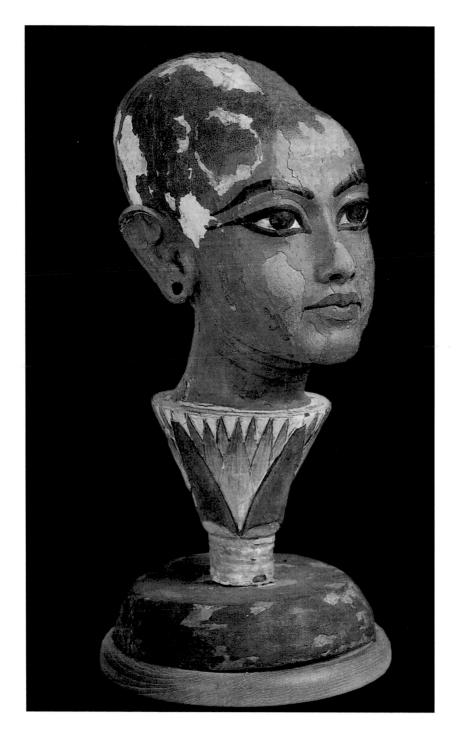

The lotus means quite the opposite in the *Cosmological Mandala with Mount Meru*. In this mandala, the circular inner frame represents a key element of Buddhist belief: the recurring loop of birth, death and reincarnation – that is, until ultimate meditation and self-awareness allow release into nirvana, a state of complete spiritual enlightenment. Mandalas are designed to be looked at in a very different way from western works of art: they are diagrams of the cosmos, with a symmetrical layout and concentric layers of squares and circles to represent zones of existence. They are used in meditation to conceptually guide the viewer from the (worldly) periphery to the (enlightened) centre.

The border areas show vases with lotuses spiralling out, and the Chinese eight treasures. Within the circle are four quadrants, each of which contains three miniature landscapes in differently shaped frames mapped out as the four cardinal compass directions. Each quadrant has been given a colour and a shape. They are arranged as follows:

North (Uttarakuru) – gold/yellow; square
East (Videha) – silver/white; semicircle
South (Jambudvipa) – lapis/blue; trapezoid
West (Godaniya) – ruby; circle

Before reaching Mount Meru, there are seven concentric squares representing mountain ranges and oceans. The Chinese symbols for **sun** (a three-legged rooster) and **moon** (rabbit) flank the central **mountain**. At the centre of the spiritual universe is the summit of Mount Meru (which is inverted so that it looks like a chalice), on which sits the divine, eight-petalled lotus.

KEY ARTWORKS

Amitābha Buddha (China), 585 CE, British Museum, London, UK
Marsh Scene, Tomb of Menna (Egypt), 1924, facsimile of original
 from c.1400–1352 BCE, Metropolitan Museum of Art, New York,
 NY, USA
Fariborz Sahba, Lotus Temple, Bahá'í House of Worship, 1986,
 New Delhi, India
Lois Conner, *Xi Hu, Hangzhou, China (Triangle Lotus)*, 1998,
 Metropolitan Museum of Art, New York, NY, USA

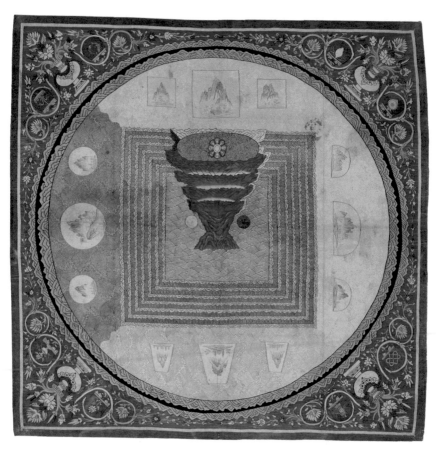

Artist unknown
*Cosmological Mandala
with Mount Meru* (China),
14th century
Silk tapestry (*kesi*),
83.8 x 83.8cm
(33 x 33 in.)
Metropolitan Museum of
Art, New York

The Chinese *Cosmological
Mandala with Mount
Meru* contains a few of
the symbols covered in
this book: mountains,
water, sun, moon and
various flowers. However,
the most important is the
motif that appears in the
centre of the scene, on
top of Mount Meru –
the axis of the world –
a lotus flower.

PALM

The symbolic value of the palm tree, like that of the **grapevine**, derives from its role as a food-bearing plant rather than its inherent beauty. The date palm was an essential element of the agriculture of ancient Assyria, and therefore it came to be seen as the 'tree of life'. This association with fertility and nutrition (and therefore victory over death) was carried into Egyptian, then Greco-Roman and ultimately Christian iconography.

In Egypt the god of eternity, Heh, held a palm branch with notches in it – each one symbolizing a year, and therefore the palm represented never-ending life. For the Greeks and Romans the palm branch was a symbol of military success, as it was an attribute of the goddess of Victory, Nike/Victoria. Jesus' triumphant entry into Jerusalem was celebrated with palm branches being strewn on the floor, henceforth celebrated as Palm Sunday. In time the palm branch became the symbol of a martyr in Christianity because it signified the defeat of death, and this developed into a general association with virtue. Thus the palm on the floor of Rossetti's *The Girlhood of Mary Virgin* is designed to remind the viewer of the future martyrdom of Mary's son Jesus.

The Girlhood of Mary Virgin was the first painting to carry the initials 'PRB', referring to the Pre-Raphaelite Brotherhood, a group of young English painters who rebelled against the artistic ideals established by the Royal Academy. The Pre-Raphaelites wanted to represent nature accurately as well as conveying spiritual ideas – a rebuttal, as they saw it, to the corrosive effects of industrialization, and its perceived threat to nature and social harmony. Inspired by the art critic John Ruskin, visual symbols were very important to the Pre-Raphaelites because they gave access to spiritual concepts and at the same time allowed for the careful study of natural form.

They looked back to artists such as Botticelli, Giovanni Bellini and Van Eyck, whose work predated the Italian painter Raphael (1483–1520) and his idealizing style. Not only does the figure of Mary's father Joachim echo the pose of Mercury in *Primavera*

Dante Gabriel Rossetti
The Girlhood of Mary Virgin, 1848–9
Oil on canvas,
83.2 x 65.4 cm
(32⅞ x 25¾ in.)
Tate, London

The palm leaf on the floor alludes to Christ's entry into Jerusalem, when, according to the Gospel of St John, 'they took palm branches and went out to meet Him, shouting Hosanna!'

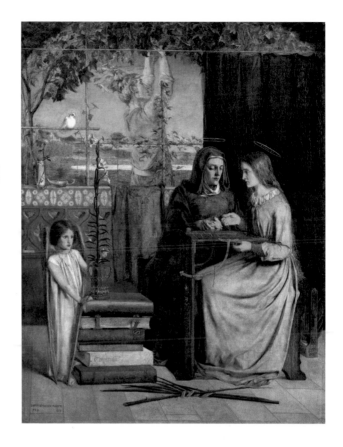

(pages 18–19), but Rossetti has also incorporated traditional visual symbols from Quattrocento Renaissance painting such as the **lily**, **dove**, **vine** and, on the floor, a thorn and palm leaf to prefigure Jesus' crucifixion. In the painting Mary is embroidering a lily, and contemplating its inner meanings just as Rossetti hoped his viewers would in front of this painting.

KEY ARTWORKS

Pashendu Praying beside a Palm Tree, Tomb of Pashendu, 1279–1213 BCE, Deir el-Medina, Egypt

Pietro Lorenzetti, *Christ's Entry into Jerusalem*, c.1320, Basilica of San Francesco d'Assisi, Assisi, Italy

Caravaggio, *The Martyrdom of St Matthew*, 1600, Contarelli Chapel, Church of San Luigi dei Francesi, Rome, Italy

Anselm Kiefer, *Palm Sunday*, 2006, Tate, London, UK

GRAPEVINE

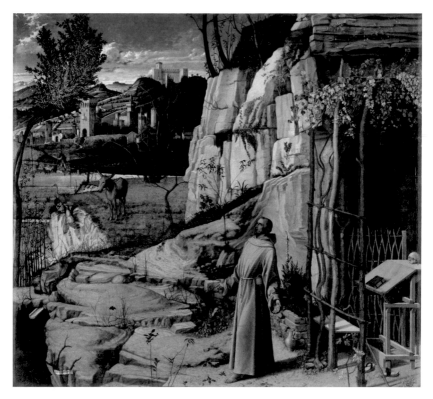

Giovanni Bellini
St Francis in Ecstasy,
c.1476–8
Oil on panel,
124.6 x 142 cm
(49 x 56 in.)
Frick Collection,
New York

St Francis stands in
awe as he receives the
stigmata – the wounds
of Christ's crucifixion.
Behind him, a well-
trained vine symbolizes
the cultivation of his
devotion to Christ. It
has been espaliered in
a manner that Dante
Gabriel Rossetti would
later echo in *The Girlhood
of Mary Virgin* (page 51).

Vine leaves are present in a range of contexts in various global religions and cultures. They were an attribute of the Egyptian god Osiris and they also feature in Buddhist iconography. In Greco-Roman culture vines, vine leaves and grapes were used to symbolize the god Dionysus/Bacchus's status as god of wine, fertility and ritual ecstasy. They can be seen adorning the borders of sculpted scenes where he is represented, forming his crown and decorating the paraphernalia of his followers.

In Christianity the vine has a very different meaning. In the Gospel of St John, Jesus proclaims: 'I am the true vine', and the plant acts as an allegory of the relationship between humans and God. Therefore the vine can either represent Christ himself or – when grapes or vines are depicted alongside corn – be used to symbolize the bread and wine of the Eucharist. In Renaissance dictionaries of emblems (*emblemata*), the vine growing up a dead elm symbolizes enduring friendship.

St Francis of Assisi (1181–1227) was renowned for his devotion to Christ and his affinity with nature and animals, aspects that are emphasized in Giovanni Bellini's *St Francis in Ecstasy*, painted in Venice between 1475 and 1480. Two plants dominate the upper part of the scene: a **laurel** of honour, which seems to crane its neck down in response to St Francis's prayer, and a grapevine, to symbolize his devotion to Christ, above St Francis's makeshift home.

Yinka Shonibare's *Last Supper (After Leonardo)*, created in London, unites the two western associations of grapevines for satiric effect. It is a scene based on Leonardo da Vinci's *Last Supper*, the event at which the rite of the Eucharist originated. However, Christ is replaced by a Dionysus/Bacchus figure with goat's legs, and whereas Leonardo's table top is neatly ordered, Shonibare's is a pandemonium of spilled grapes, overturned champagne glasses, dismembered joints of meat and garishly coloured tulips.

KEY ARTWORKS

Head of Dionysos (ancient region of Gandhara, now in Pakistan), 4th–5th century CE, Metropolitan Museum of Art, New York, NY, USA

Peter Paul Rubens, *Bacchus*, 1638–40, State Hermitage Museum, Saint Petersburg, Russia

Jerzy Siemiginowski-Eleuter, *Allegory of Autumn*, 1680s, Wilanów Palace Museum, Warsaw, Poland

Grinling Gibbons, limewood altar screen, 1684, St James's Church, Piccadilly, London, UK

Yinka Shonibare
*Last Supper (After
Leonardo)*, 2013
Thirteen life-size
mannequins, Dutch
wax, printed cotton,
reproduction wood table
and chairs, silver cutlery
and vases, antique and
reproduction glassware
and tableware, fibreglass
and resin food,
158 x 742 x 260 cm
(62¼ x 292 x 102½ in.)
Stephen Friedman
Gallery, London

**The bacchanalia
theme was selected
to remind viewers of
historical hedonism
and excess such as in
pre-Revolutionary France
(the figures are headless
as a reminder of the
executions during the
Reign of Terror), but
also the contemporary
disparity between wealth
and poverty that lay at
the heart of the 2007–8
global banking crisis.**

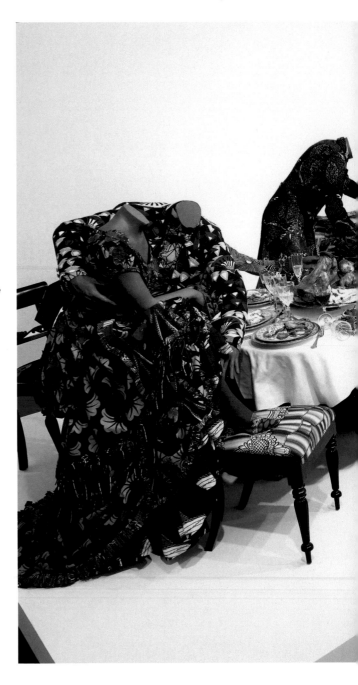

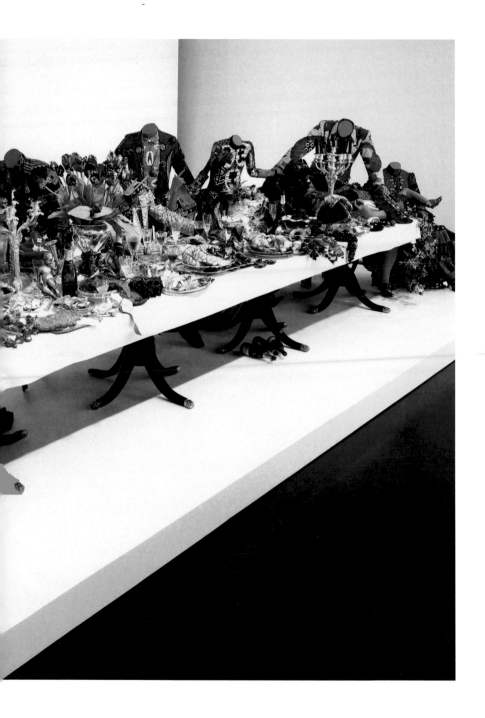

POPPY

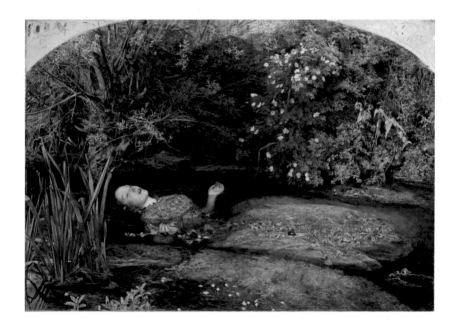

Opium is derived from the seed-heads of poppies, so they are
frequently seen as a symbol of the effects of opium: sleep,
degeneracy and, by extension, death. Hypnos, the Greek god of
sleep, and Nyx, the Renaissance allegory of the night, have a poppy
as their attribute. However, in Christian art the poppy's saturated
red hue led to its use as a symbol of the blood of Christ.

The sacrificial connotations continue into modern-day contexts
too. In Britain, Australia, New Zealand, Canada and the Republic
of Ireland artificial remembrance poppies are worn during the
anniversary of the end of the First World War to commemorate
those killed in military action.

The largest flower floating on the surface of the water in Sir John Everett Millais's *Ophelia* is a red poppy, symbolizing Ophelia's death by drowning. Painted in London, it is a scene inspired by Shakespeare's *Hamlet* (c.1600), in which the young Ophelia is driven mad by grief after her father is accidentally killed by her former suitor, Hamlet. While delirious with sorrow, Ophelia hands flowers out to members of the court, explaining the symbolic meaning of each. Later she falls into a brook and drowns. However, the death scene is not shown in the play, only described by Queen Gertrude who announces the details of the tragedy. It is this scene that Millais has visualized, using as inspiration the evocative description about how Ophelia:

Sir John Everett Millais
Ophelia, 1851–2
Oil on canvas, 76.2 x
111.8 cm (30 x 44 in.)
Tate, London

Fell in the weeping brook. Her clothes spread wide,
And mermaid-like awhile they bore her up . . .
 Till that her garments, heavy with their drink,
Pulled the poor wretch from her melodious lay
To muddy death.

**Millais spent months
painting in the open air
beside a brook in Surrey
in order to capture the
details of nature with
sufficient accuracy.
The poppy stands out
because red and green are
complementary colours.**

Millais was a member of the Pre-Raphaelite Brotherhood, for whom the language of symbols was fundamental (see *The Girlhood of Mary Virgin* by Dante Gabriel Rossetti on page 51). In *Ophelia* most of the meticulously depicted flowers have a specific meaning that was defined in Shakespeare's play. However, some flowers, such as the poppy, were not mentioned in *Hamlet*, so Millais's Victorian audiences would have had to consult one of the many recently published books on floral symbolism, such as Mary Anne Bacon's *Flowers and their Kindred Thoughts* (1848), to interpret the image.

KEY ARTWORKS

Marble sarcophagus with the myth of Selene and Endymion
 (Roman), early 3rd century CE, Metropolitan Museum of Art,
 New York, NY, USA
Paolo Veneziano, *Madonna of the Poppy*, c.1325, San Pantalon,
 Venice, Italy
Michelangelo, *Night*, 1526–31, New Sacristy, Basilica of San
 Lorenzo, Florence, Italy
Paul Cummins and Tom Piper, *Blood Swept Lands and Seas of Red*,
 2014, temporary site-specific installation at Tower of London,
 London, UK

SUNFLOWER

Sunflowers are native to the Americas, and they were only
introduced to Europe in the sixteenth century. They soon became
an artistic symbol of devotion, because the faces of immature
sunflowers follow the course of the **sun** across the sky. In Sir
Anthony van Dyck's *Self-Portrait with Sunflower* the plant is posed
like a second sitter, echoing the artist's gaze, its upper petals swept
insouciantly inwards just like the strands of hair on Van Dyck's
forehead. The **hand gestures** reinforce this connection, but the
artist's left hand also casually proffers the gold chain that hangs
around his neck. This was given to Van Dyck by King Charles I of
England when the artist was knighted and made the king's principal
painter. The sunflower therefore symbolizes his steadfast loyalty
to the sovereign, an idea probably taken from one of the various
emblem books available during the seventeenth century. As with a
few other paintings in this book, Van Dyck's iconography would have
only been decipherable to an elite, art-loving coterie.

The cultivation of sunflowers was thought to have occurred
around 3,000 BCE in the southern regions of North America.
Dorothea Tanning painted *Eine Kleine Nachtmusik* in exactly this
region – known by then as Arizona – while living with her partner
and future husband, Max Ernst (see *Men Shall Know Nothing of This*
on page 26).

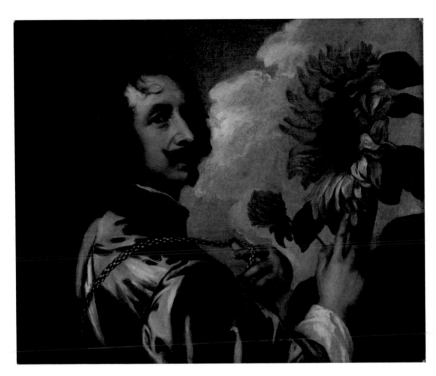

Sir Anthony van Dyck
Self-Portrait with
Sunflower, 1633
Oil on canvas, 73 x 60 cm
(29 x 24 in.)
Private collection

Although we have few means to verify the interpretation, it is generally accepted that the sunflower in Van Dyck's self-portrait is intended to symbolize the artist's loyalty to King Charles I of England.

In Dorothea Tanning's hand the sunflower expresses personal and psychological ideas. She has stated that she connected the flower with the oppressively fierce Arizona sun, explaining that:

> It's about confrontation. Everyone believes he/she is his/ her drama. While they don't always have giant sunflowers (most aggressive of flowers) to contend with, there are always stairways, hallways, even very private theatres where the suffocations and the finalities are being played out . . .

In an approach that is broadly characteristic of artists in the twentieth and twenty-first centuries, Tanning has jettisoned conventional iconography in *Eine Kleine Nachtmusik* (opposite) and instead used symbols that have a private and therefore an ominously ambiguous resonance.

KEY ARTWORKS

Bartholomeus van der Helst, *Portrait of a Lady with a Sunflower*, 1670, private collection

Charles de la Fosse, *Clytie Transformed into a Sunflower*, 1688, Grand Trianon, Versailles, France

Vincent van Gogh, *Sunflowers*, 1888, National Gallery, London, UK

Egon Schiele, *Sunflower II*, 1910, Wien Museum, Vienna, Austria

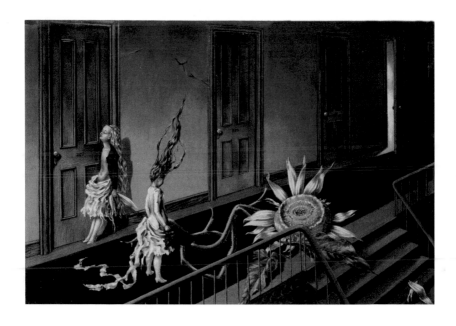

Dorothea Tanning
Eine Kleine
Nachtmusik, 1943
Oil on canvas,
40.7 x 61 cm
(16 x 24 in.)
Tate, London

Through the flower
Tanning can hint at the
presence of an undefined
barbarism affecting
the two young girls,
especially through the
detail of the two yellow
petals ripped from the
sunflower head. The
point at which they
have been detached also
suggestively aligns with
the opening bedroom
door along the corridor.

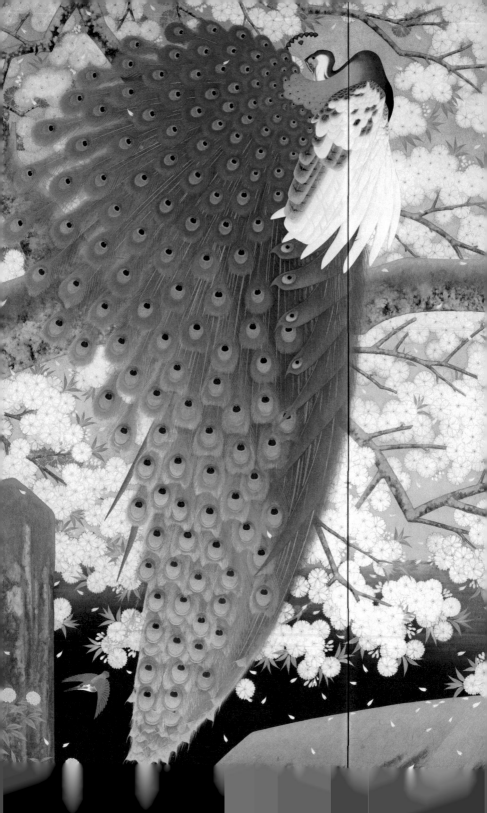

BIRDS

-

**How do you know but ev'ry Bird that
cuts the airy way,
Is an immense world of delight,
clos'd by your senses five?**

-

William Blake
1793

DOVE

El Greco
Annunciation, 1597–1600
Oil on canvas,
315 x 174 cm
(124 x 68½ in.)
Prado, Madrid

**In later Christian
iconography the dove
became a symbol of the
Holy Spirit. Thus it can
sometimes be found as
decoration in churches
and within scenes such as
El Greco's *Annunciation*
painted in Spain.**

In many global cultures, doves are associated with positive qualities such as peace and the human soul, unlike other birds in this book such as the **eagle** and **falcon**, which are generally symbols of status and power. Doves can be seen in works of art created in some of the oldest known societies, commonly in the presence of powerful female goddesses of fertility and sex such as Inanna (in Sumerian culture), who was also known as Ishtar (in the Akkadian empire of Mesopotamia, c. 2334–2154 BCE) and Astarte (by the Phoenicians, c.2500–539 BCE). Likewise the dove is also an attribute of the Greco-Roman goddess of love Aphrodite/Venus. In the Han dynasty in China doves appeared as a symbol of well-being, and in Japan they are associated with unity.

 In early Christian tombs a dove with an olive branch represented the soul resting in peace in heaven. This came from the story of Noah in the Old Testament Book of Genesis where a returning dove with an olive twig signified the concord between God and humanity.

KEY ARTWORKS

Finial ornament in the form of a dove (China), c.206 BCE–220 CE, Ashmolean Museum, Oxford, UK

Ceiling mosaic, early 6th century, Arian Baptistry, Ravenna, Italy

Titian, *Venus and Adonis*, 1550s, Metropolitan Museum of Art, New York, NY, USA

Banksy, *Armoured Dove of Peace*, 2007, West Bank Wall, Israel/Palestine

Pablo Picasso
Colombe avec Fleurs, 1957
Coloured pencil on paper,
50 x 65 cm
(19¾ x 25⅝ in.)
Private collection

Picasso recounted at a Peace Congress in Sheffield in 1950 how his father had taught him to paint doves, and concluded: 'I stand for life against death; I stand for peace against war.'

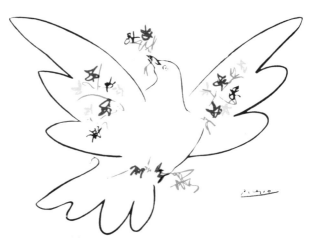

EAGLE

In Kehinde Wiley's portrait of *Ice-T*, an **eagle's** head and wings are just visible beneath the legendary rapper's feet. An eagle is a symbol of power, most famously as the emblem of the Roman emperors and their armies. The people of Rome accepted the eagle as the most exalted of birds because Jupiter, their supreme deity and the king of their pantheon of gods, had an eagle as his attribute. Prior to this, eagles were divine symbols in Sumerian culture and Zoroastrianism. Since the Romans, an eagle has been re-used as a motif for numerous empires including the Holy Roman empire (800–1806 CE), the Napoleonic empire (1804–15 CE) and the Russian empire (1721–1917 CE). Wiley's painting includes many symbols, but the eagle is the one with the longest history behind it.

Ice-T was commissioned by the music channel VH1, and is one of a series of portraits of iconic stars that Wiley painted for the Hip Hop Honors awards in 2005. In common with many other images by Wiley, a contemporary black figure has been inserted into a famous painting from the western canon, as a way to disrupt our expectations and make us rethink the visual language of power and male self-presentation.

Before undertaking the project Wiley met with Ice-T to share thoughts on how the rapper should be represented. 'He had the most shocking level of ego and excess,' Wiley later stated. 'It was me inviting these celebrities to be who they wanted to be, and he goes straight for a portrait of Napoleon. He was, like, "If anyone deserves to be Napoleon, it's me. I'm the father of gangster rap." So he crowned himself.'

The portrait of Napoleon chosen by Ice-T was Ingres' *Napoleon on his Imperial Throne*, and Wiley has not made major adaptations to the details of the original. One telling alteration has occurred however: the sceptre of Charlemagne, which Napoleon holds in his left hand, has its tip resting on the wing of the eagle in Ingres's version. In Wiley's, it points to the eagle's head, and Ice-T's left index finger point, much more assertively downwards, drawing our attention to the powerful symbol below.

Kehinde Wiley
Ice-T, 2005
Oil on canvas, 243.8 x 182.9 cm (96 x 72 in.)
Private collection

Wiley recycled and adapted Jean-Auguste-Dominique Ingres's 1806 *Napoleon on his Imperial Throne* to show Ice-T as the almighty emperor of hip hop, complete with all the traditional symbols of authority.

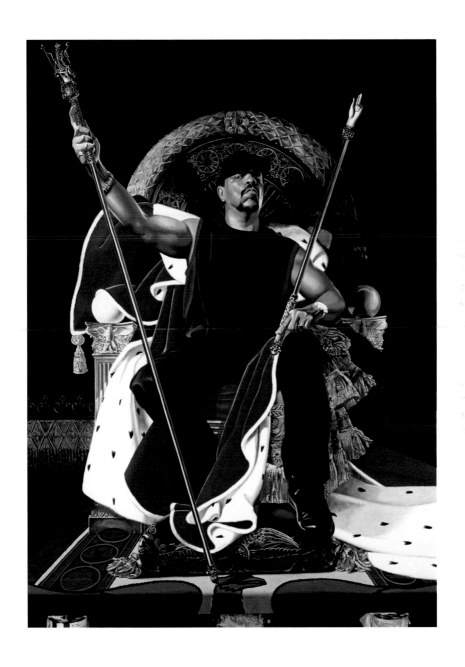

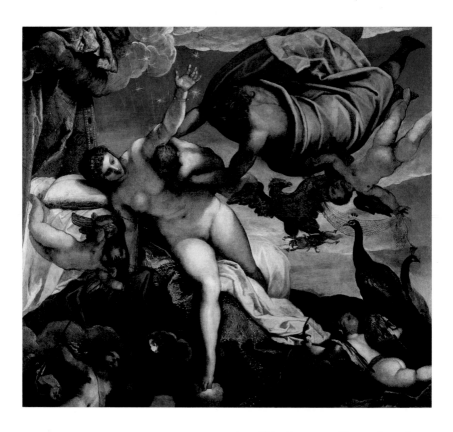

Jacopo Tintoretto
The Origin of the Milky Way, c.1575
Oil on canvas, 149.4 x 168 cm (58¾ x 66 in.)
National Gallery, London

Tintoretto has used Jupiter's and Juno's attributes – the eagle and peacock – to identify the pair in this story of the Milky Way's creation. The painting has been cut down: once it showed lilies growing where Juno's breastmilk hit the earth.

Wiley's act of artistic appropriation is not without precedent in western culture. In fact Ingres had himself adopted the composition and pose of previous works of art – including Phidias's colossal sculpture of *Zeus* at Olympia (c.435 BCE) and Jan van Eyck's representation of God the Father on the *Ghent Altarpiece* (1432) – to invest his image with power. In conventional depictions of Zeus/Jupiter, such as Tintoretto's *The Origin of the Milky Way*, the god is often shown above an eagle that grasps a **lightning** bolt. This links to the Roman belief that an eagle would transport the soul of an emperor to heaven after his death.

In Tintoretto's painting Jupiter is shown taking his illegitimate son Hercules to be surreptitiously fed at the breast of the sleeping goddess Juno, a story connected to the creation myth of the Milky Way and the **lily** (see page 44). Meanwhile Jupiter's impertinent eagle calls out to Juno's attribute, a suitably unimpressed **peacock**.

KEY ARTWORKS

Relief panel showing an eagle-headed divinity (Neo-Assyrian), c.883–859 BCE, Metropolitan Museum of Art, New York, NY, USA

Nicolas Poussin, *Landscape with St John on Patmos*, 1640, The Art Institute of Chicago, Chicago, IL, USA

Jacques-Louis David, *The Distribution of the Eagle Standards*, 1810, Château de Versailles, Versailles, France

Robert Rauschenberg, *Canyon*, 1959, Museum of Modern Art (MoMA), New York, NY, USA

OWL

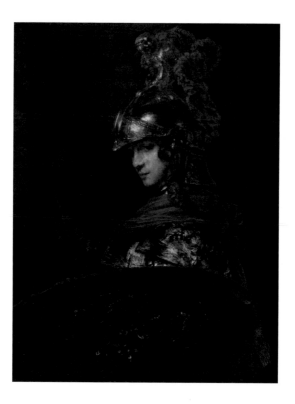

A bird of the night, the owl is connected with darkness and death in Maori, Babylonian, Chinese, Japanese and Hindu iconography. It is therefore the only bird in this chapter with a widely negative set of associations, quite unlike the regal **eagle**, peaceful **dove**, noble **crane** and agile **falcon**. An Ancient Mesopotamian sculpture in the British Museum known as the *Burney Relief* (c.1800–1750 BCE) is a striking early example of this link to the sinister, showing a chthonic goddess flanked by owls. In other contexts, however, owls are associated with wisdom, for example, as the attribute of Athena/Minerva, who was the Greco-Roman goddess of tactical warfare as well as learning. In Renaissance art owls also allegorically represent sleep, for example in Michelangelo's *Night* (1526–31) in the New Sacristy of the Basilica of San Lorenzo in Florence, where an owl sits beside a bunch of sleep-inducing **poppy** heads.

Rembrandt van Rijn
Pallas Athena, 1657
Oil on canvas, 118 x 91 cm
(46½ x 35¾ in.)
Calouste Gulbenkian
Museum, Lisbon

Rembrandt's *Pallas Athena*, painted in the Dutch Republic, uses a typical set of attributes for the goddess including a shield decorated with Medusa's head, and a golden owl fixed to the top of her helmet.

The Pre-Columbian owl staff head, created in what is now northern Colombia, was made of gold, which was considered to be the 'sweat of the **sun**'. Although comparatively little is known of Zenú iconography, it is likely that the owl was considered to be a divine creature and perhaps its use on this staff owned by a Zenú priest or chieftain inferred divine power. In contrast with the other Pre-Columbian civilizations that surrounded them, the Zenú represented animals as benign and protective, rather than as ferocious or vengeful beings.

KEY ARTWORKS

Burney Relief (Mesopotamia), 1800–1750 BCE, British Museum, London, UK

Tetradrachm coin with owl of Athena on reverse (Greek), 594–527 BCE, British Museum, London, UK

Francisco de Goya, *The Sleep of Reason Produces Monsters* (No. 43), from *Los Caprichos*, 1799, prints can be found in the Nelson-Atkins Museum of Art, Kansas City, MO, USA, and many collections worldwide

Paul Nash, *Totes Meer (Dead Sea)*, 1940–41, Tate, London, UK

Artist unknown
Owl staff head (Zenú),
1–1000 CE
Gold, 12.1 x 6.7 x
4.5 cm (4¾ x 2⅝ x
1¾ in.)
Metropolitan Museum
of Art, New York

The owl on the tip of this ceremonial staff would have been a status symbol for the Zenú priest or chieftain who owned it.

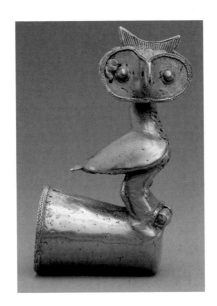

PEACOCK

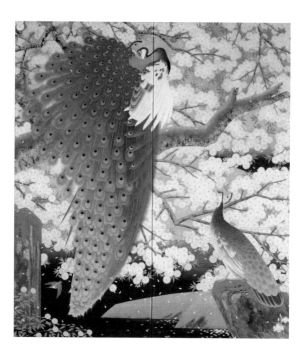

Peacocks are synonymous with royalty in India, China and Iran and are sometimes depicted as the mount of Brahma, Buddha and the Hindu war god Kartikeya/Skanda. The natural grace and dazzling colour of peacocks have made them natural symbols of beauty throughout Asia and Europe, and this is often the primary focus of works that contain them, including Imazu Tatsuyuki's *Peacocks and Cherry Tree*. In Japan they also symbolize good fortune because of their association with Buddhist deities, fertility and abundance because of the countless 'eyes' on their feathers, and protection because peacocks eat snakes.

In Greco-Roman mythology the regal peacock was the attribute of the queen of the gods Hera/Juno. In this mythological narrative, the peacock's distinctive feather patterns were given to the bird after the death of its servant, the 100-eyed giant Argus. Peter Paul Rubens's portrait of Marie de' Medici and Henry IV of France dignified both sitters by associating them with these supreme classical deities: Zeus/Jupiter's **eagle** is visible in the upper left-hand corner, counterpointing Hera/Juno's peacock.

Imazu Tatsuyuki
Peacocks and Cherry Tree, c.1925
Two-panel folding screen; mineral colours and metallic powders on paper, 203.5 x 185 cm (80⅛ x 72⅞ in.)
Metropolitan Museum of Art, New York

Tatsuyuki shows a peahen admiring the opulent patterns of a peacock on this finely painted screen.

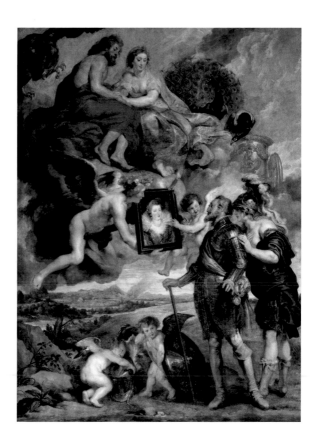

Peter Paul Rubens
*Henry IV Receives the
Portrait of Maria de'
Medici*, 1622–5
Oil on canvas, 394 x
295 cm (155 x 116 in.)
Louvre, Paris

**Rubens is using the
conventional attributes
to represent the gods in
this painting: an active,
lightning bolt-carrying
eagle for Zeus/Jupiter
and a resplendent but
passive peacock for
Hera/Juno.**

In Christian iconography peacocks were linked to immortality because their flesh was rumoured to never decay, and resurrection because their feathers renewed. They also symbolized heaven because the 'eyes' on their feathers were seen to resemble stars: these notions led to the inclusion of a peacock in such paintings as Fra Angelico and Fra Filippo Lippi's *The Adoration of the Magi* (c.1440–60).

KEY ARTWORKS

Skanda on his Peacock, 7th century CE, Musée National des Arts Asiatiques-Guimet, Paris, France

Fra Angelico and Fra Filippo Lippi, *The Adoration of the Magi*, c.1440–60, National Gallery of Art, Washington, DC, USA

Carlo Crivelli, *Annunciation with St Emidius*, 1486, National Gallery, London, UK

William Morris, *Peacock and Dragon* curtains, 1878, Victoria and Albert Museum, London, UK

PHOENIX

A phoenix is a mythological creature that is supposed to live for 500 years, after which time it incinerates itself so that it can be reborn from the ashes. A phoenix is also unique as there is only ever one in the world at any given time. The word 'phoenix' is Greco-Roman, and different cultures have alternative names for similar creatures. It is 'bennu' to the ancient Egyptians, 'feng huang' to the Chinese and 'si-murg' to the Persians. In China a phoenix symbolized benevolent leadership, and it was the emblem of the empress, while a **dragon** was the symbol of the emperor. In China the phoenix was also one of the four guardians of the universe, alongside the **dragon**, unicorn and tortoise. Its power to self-renew has led to it becoming a visual metaphor for rejuvenation, an animal equivalent of **water** and **cypress** trees in signifying longevity and resilience to decay.

The link to renewal is clear in Christian iconography where phoenixes are associated with the resurrection of Jesus. It is in this context that the phoenix appears on the exterior of St Paul's Cathedral in London with the Latin inscription 'RESURGAM' (I shall rise again). The present cathedral is a replacement for a previous structure that was destroyed by the Great Fire of London in 1666. The fire began in a London bakery and rapidly spread to engulf the whole city, leaving eighty per cent of its buildings devastated. This was a catastrophe for the majority of Londoners, but a unique opportunity for the architect Sir Christopher Wren who supervised the rebuilding of St Paul's and fifty-one other churches in the City of London. The cathedral was ready for use after an incredibly short thirty-six-year building programme.

Caius Gabriel Cibber
Resurgam phoenix relief,
1675–1711
Portland stone
St Paul's Cathedral,
London

The ideal symbol to attach to St Paul's Cathedral's south pediment was a phoenix, to demonstrate the rapid rejuvenation of London and the irrepressibility of the Christian (and more specifically, Protestant) faith following the destruction of the previous cathedral in the Great Fire of London in 1666.

KEY ARTWORKS

Phoenix, from *The Aberdeen Bestiary*, 12th century, University of Aberdeen, Aberdeen, Scotland

Tile with image of a phoenix (Iran), late 13th century, Metropolitan Museum of Art, New York, NY, USA

Panel with Phoenixes and Flowers (China), 14th century, Metropolitan Museum of Art, New York, NY, USA

James Gillray, *Napoléon Bonaparte ('Apotheosis of the Corsican-phoenix')*, 1808, National Portrait Gallery, London, UK

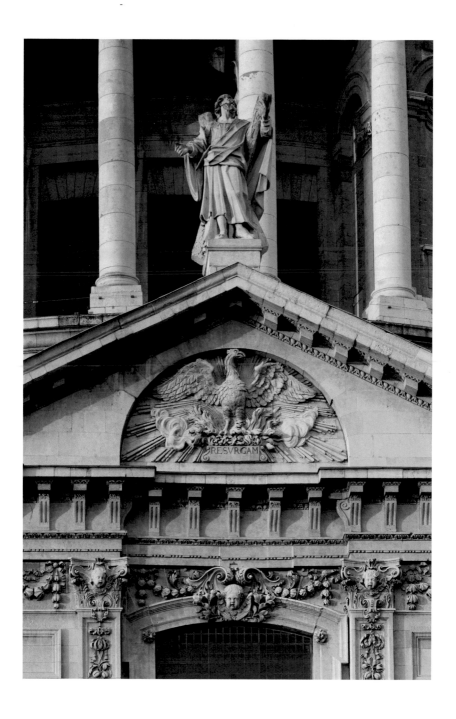

FALCON

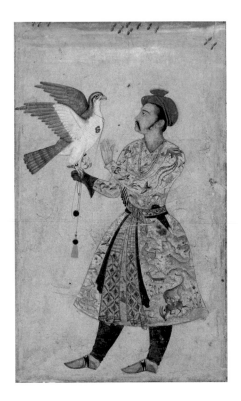

Falcons are synonymous with social elites in Europe and Asia, and they are included in many portraits to dignify the human sitter, as in *Prince with a Falcon*, painted in India. Here birds are the predominant symbol, not just the falcon to whom even a Mughal prince looks up with respect: the man's magnificent yellow garment is festooned with majestic birds above his belt, including **cranes** and a **phoenix**.

Falconry was a sport for the wealthy and powerful: in the thirteenth century, Marco Polo observed that the Mongol emperor Kublai Khan had a retinue of 70,000 men to accompany his hunts with birds of prey. The expense of such an undertaking naturally led to falcons being associated with leadership and prestige. But the falcons' inherent animal qualities – high flying, agile and keen sighted – meant that they were also a symbol of a noble spirit. In Japan and China the word for 'falcon' is a homophone for 'heroic'.

Artist unknown
Prince with a Falcon
(India), c.1600–5
Opaque watercolour, gold
and ink on paper, 14.9 x
9.5 cm (5⅞ x 3¾ in.)
Los Angeles County
Museum of Art,
Los Angeles

The falcon takes centre stage in this small image, signifying its high status as a possession of the ruling class. The Mughal prince's reactions are telling: he gives it a placatory look and an entreating hand gestures suggesting that this is no common pet.

In Ancient Egypt falcons had supreme significance, as they were associated with the god-king Horus, who could be shown as a falcon or with a falcon's head. But they were also linked with other gods such as Re, Montu, Khonsu and Sokar. Indeed the hieroglyph for falcon represented the word 'god'.

The Egyptian pectoral (below) features two prominent falcons. It was made with gold and 372 finely cut pieces of carnelian, lapis lazuli, turquoise and garnet. Just smaller than a credit card, it would have been worn on a necklace, probably by a princess.

Artist unknown
Pectoral without the necklace (Egypt), front, c.1887–1878 BCE
Gold, carnelian, feldspar, garnet, turquoise and lapis lazuli, 4.5 x 8.2 cm (1¾ x 3¼ in.)
Metropolitan Museum of Art, New York

At the centre of this pectoral, the crest of Pharaoh Senwosret II and the falcons, who are holding shen rings of protection, symbolize the gods' support for his rule.

KEY ARTWORKS

Falcon with Ram's Head Amulet (Egypt), c.1550–1069 BCE, Louvre, Paris, France

The Falcon's Bath Tapestry, c.1400–15, Netherlands, Metropolitan Museum of Art, New York, NY, USA

Pintoricchio, *Penelope with the Suitors*, c.1509, National Gallery, London, UK

Kesu Das, *Akbar with Falcon Receiving Itimam Khan, while below a Poor Petitioner Is Driven Away by a Royal Guard*, page from a Jahangir Album, 1589, Staatsbibliothek, Berlin, Germany

CRANE

In China and Japan the crane is a recurring religious, poetic and artistic motif. Cranes have a natural willowy grace that is well demonstrated during their distinctive mating dance, and they are capable of soaring high into the atmosphere. They are therefore a symbol of elegance, ascendance, spiritual enlightenment, personal ambition and (like a **phoenix**) longevity. As an emblem of the latter they are often shown in Chinese art in combination with a pine tree and tortoise, which are also symbols of endurance. As high-altitude birds, they were also thought to usher the dead to heaven, and to act as messengers for the gods.

Portrait of an Imperial Censor and his Wife from Qing-dynasty China contains several visual symbols, including the mythological creatures on the pair's courtly uniforms which indicate that the husband held a position of great honour within the Chinese civil service. The most auspicious symbols in the scene are those that suggest the couple's wish for continued long life and success: the overhanging pine tree in combination with the pair of red-crowned cranes in the foreground.

In Europe the crane is sometimes shown as an attribute of duty and watchfulness. It was believed that in a group of cranes, one would always stay awake and keep guard; it would hold a stone in its claw so that if it dozed off, it would drop the stone and be woken by the sound. This is a common motif in heraldry, and a prominent feature of Raphael's design for the tapestry *The Miraculous Draught of Fishes* (1515), commissioned to hang in the Sistine Chapel, Rome.

Origami cranes are a symbol of peace in Japan. This stems from the story of Sadako Sasaki who was a two-year-old victim of the nuclear bombing of Hiroshima in 1945. She was exposed to radiation, contracted leukaemia and eventually died at the age of twelve. In the final few months of her life she made 1,000 origami paper cranes, having been told by her father the Japanese legend that doing so would bring a wish to life.

Artist unknown
Portrait of an Imperial Censor and his Wife, late 18th–early 19th century
Hanging scroll; ink and colour on silk, image: 163.8 x 98.7 cm (64½ x 38⅞ in.)
Metropolitan Museum of Art, New York

In China the crane is a good omen, bringing happiness. They were believed to live for a long time, and the fact that they returned in the springtime has linked them to regeneration.

KEY ARTWORKS

Attributed to Emperor Huizong, *Auspicious Cranes*, c.1112, Liaoning Provincial Museum, Shenyang, China

Cranes, page from Edward Harley, *Bestiary*, 13th century, British Library, UK

Domenico Beccafumi, *Venus and Cupid,* c.1530, New Orleans Museum of Art, New Orleans, VA, USA

Sadako Sasaki, *Paper Cranes*, 1955, Hiroshima Peace Memorial Museum, Hiroshima, Japan

BEASTS

-

**The symbol is a key to a realm
greater than itself and greater
than the man who employs it**

-

J. C. Cooper
1978

CAT

The cat playing with an injured bird under the table in *The Awakening Conscience* is the most significant of the painting's many discreet symbols because it reveals its overall meaning in microcosm. We are in a fashionable living room, where an unmarried couple is having an intimate moment: it is a modern setting for an age-old sin. In a twist on the conventions of such images, however, the woman is in charge of her own destiny. Realizing the error of her ways she is standing, moving away from her lover and seeing beauty and simplicity as if for the first time in the verdant nature of the garden, visible to us in the large **mirror** in the background. The cat is a manifestation of the man's perfidious intentions.

After *The Awakening Conscience* had been exhibited at the Royal Academy in 1854, the distinguished art critic John Ruskin wrote to *The Times* in irritation that the majority of the people who saw the painting had not been able to understand its covert symbols. He dutifully explained several of them, including the cat, the wallpaper decorated with predatory birds eating corn while the love-god Cupid sleeps and the white garden flowers that signify the woman's call to purity. Hunt's characterization of his cat as wild-eyed rogue is not unusual in western art: cats have frequently been associated with satanic mischief, witches and misfortune. In Domenico Ghirlandaio's *Last Supper* (1480) from the convent of San Marco in Florence, for example, a cat is shown beside Judas to emphasize his evil nature. Cats are not mentioned once in the Bible.

William Holman Hunt
The Awakening Conscience, 1853
Oil on canvas,
76 x 56 cm (30 x 22 in.)
Tate, London

Hunt exhibited this at the Royal Academy at the same time as his *The Light of the World*, which depicted Christ knocking on an unopened door. As a pair they exhibit aspects of Christian morality, and symbols were a key part of Hunt's method of communication.

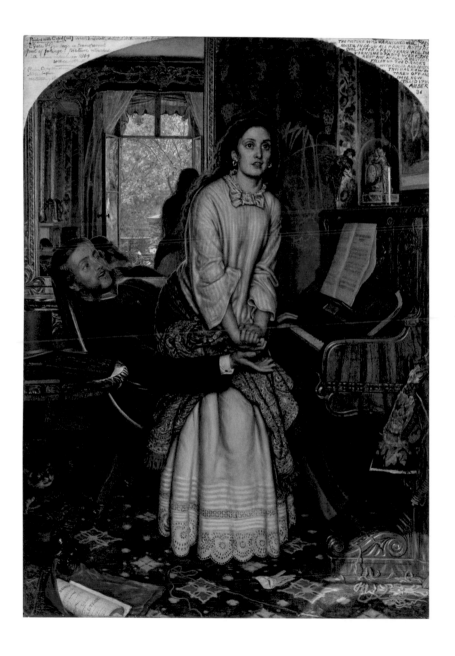

Artist unknown
Cat Statuette,
332–30 BCE
Leaded bronze,
32 x 11.9 x 23.3 cm
(12⅝ x 4⅝ x 9⅛ in.)
Metropolitan Museum
of Art, New York

**Large numbers of cat
statuettes such as
this one have been
found in Egyptian
temples dedicated to
the goddess Bastet.
Each was intended to
contain a mummified cat.
A small hole in its right
ear shows that it once
wore a gold earring.**

In other cultures cats are not so maligned. In China they are associated with healing and fortune telling (even though various legends describe cat demons who robbed victims of wealth and property). In Ancient Egypt they had an especially high status and were represented as deities. Bastet was the main cat goddess and she was worshipped as a maternal protector, often being depicted in imagery killing Apep, the underworld **snake** deity. It is believed that cats were first domesticated in Ancient Egypt (and the Fertile Crescent), and that their usefulness as killers of household vermin led to their veneration as guardians against chaos. The sleek *Cat Statuette* was probably the container for a mummified pet cat, left as an offering by a family in one of Bastet's temples. It probably once sported real jewellery as well as an incised wedjat-**eye** necklace.

KEY ARTWORKS

Cat with a Quail mosaic, c.2 CE, National Archaeological Museum
 of Naples, Naples, Italy
Hendrick Goltzius, *The Fall of Man*, 1616, National Gallery,
 Washington, DC, USA
Édouard Manet, *Olympia*, 1863, Musée d'Orsay, Paris, France
Théophile Steinlen, *The Chat Noir*, 1896, Van Gogh Museum,
 Amsterdam, Netherlands

DEER/STAG

Rather like the **crane**, deer are generally represented in art as ethereal and mystical creatures. They have been revered in Japan since prehistoric times, as *Deer Bearing a Sacred Mirror of the Five Kasuga Honji-Butsu* and its platform of celestial **clouds** confirms. The sculpture was created as an offering at the Kasuga shrine in Nara, southern Japan. Not far from this shrine is Mount Mikasa, where, according to legend, the god Takemikazuchi-no-Mikoto was transported by a celestial deer. The real deer that inhabit the park surrounding the Kasuga Shrine are protected as divine creatures and are still allowed to roam free. In this sculpture there are various sacred objects including a sakaki tree and a mirror with five Buddhist versions of Shinto gods. Buddhism was introduced to Japan from China in about the ninth century CE, and the sculpture documents the interface of existing beliefs with imported ones.

In Greco-Roman myth, deer are either the graceful escorts or elegant victims of powerful owners. The attribute of the huntress goddess Artemis/Diana is a stag, and her retribution on Actaeon for accidentally seeing her bathing was to transform him into one so that her hunting **dogs** could devour him. Aphrodite/Venus, Athena/Minerva and Apollo are also associated with deer at various times in their roles as hunters.

Artist unknown
Deer Bearing a Sacred Mirror of the Five Kasuga Honji-Butsu, c.14th century
Gilt bronze, height 116 cm (45½ in.)
Hosomi Museum, Osaka

As a work of art, this sculpture has a stunning sense of presence: the sculptor's commitment to anatomical accuracy is the product of a deep regard for nature, inspired by religion.

In *Gibbons and Deer* (below), the function of the animals within the scene is quite different from most of the other examples in this book. Overall the painting is an example of a rebus: a puzzle where various images, when spoken aloud, form a word or sentence. In Chinese the word for gibbons sounds the same as 'first' and the word for deer sounds the same as 'power'. Here the painting was recognized as a message wishing the recipient good luck in the civil service exams, where first place brings wealth and authority.

Artist unknown
Gibbons and Deer
(China), 1127–1279
Album leaf; ink and colour
on silk, 17.8 x 22.2 cm
(7 x 8¾ in.)
Metropolitan Museum
of Art, New York

**The animals in this
Chinese painting are
not strictly speaking
symbolic, but are the
centre of a puzzle with
a meaning.**

KEY ARTWORKS

Cave painting of a megaloceros, c.16,000–14,000 BCE, Lascaux, France

Pisanello, *The Vision of St Eustace*, c.1438–42, National Gallery, London, UK

Titian, *The Death of Actaeon*, c.1559–75, National Gallery, London, UK

Frida Kahlo, *The Wounded Deer*, 1946, Carolyn Farb Collection, Houston, TX, USA

DOG

Modern attitudes towards dogs mirror those of the Ancient Greeks
and Romans. Then as now, dogs were highly prized – but in a way
quite unlike the other animals in this book: they were possessions.
Thus they feature in art as beloved and faithful pets, protectors of
property and excellent hunting companions with their heightened
senses of sight and smell. This is in stark contrast to Ancient Greek
attitudes towards **cats**, which were not kept as pets or generally
considered worthy of esteem. Various mythological hunters, such
as Orion and Artemis/Diana, kept hounds. Dogs were considered
to possess intelligence, a quality that was singled out for praise by
Plato, and they were seen as empathetic and loyal creatures who
could display human characteristics. Many dog owners, including
the Homeric hero Odysseus, gave their pets human names.

Dogs were sometimes associated with magic and healing,
as their licks were believed to cure sores. Asclepius, the Ancient
Greek god of medicine, was sometimes represented with a canine
follower. It was also believed that a faithful dog would accompany
its owner even after death, and there is evidence of dogs being
buried alongside their owners in Greece going back as far as the
Iron Age. Tomb sculptures from later periods in Greek history
sometimes incorporated cherished pet dogs, and in Greco-Roman
mythology the guardian of the underworld was a three-headed dog
named Cerberus.

These beliefs stemmed from earlier religions in the Middle
Eastern region: the Ancient Babylonian healer-goddess Gula was
represented with a canine companion, and sometimes she was
shown having assumed the form of a dog. Zoroastrians, meanwhile,
foreshadowed Greek beliefs that dogs were companions to the
hereafter, and the Egyptian god Anubis watched over and judged
dead souls.

Importantly, however, dogs have not had consistently positive
associations, and they were sometimes also considered by
philosophers such as Aristotle to be outcasts and reprobates. They
were certainly deemed to be pariahs in the Middle East. This is
captured in biblical attitudes towards dogs, which are generally

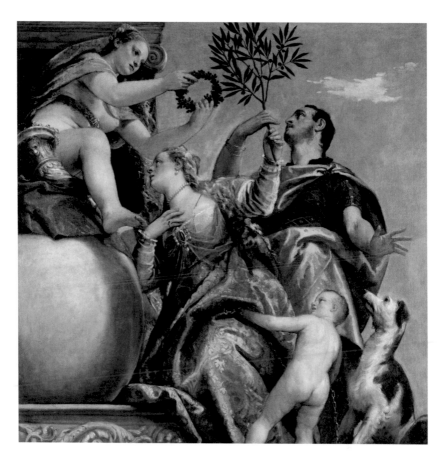

Paolo Veronese
Happy Union from
Allegories of Love, c.1575
Oil on canvas,
187.4 x 186.7 cm
(73¾ x 73½ in.)
National Gallery, London

In the bottom right-hand
section, a *putto* begins
to secure a gold chain of
matrimony around the
couple, and beside him is
a dog leaning gracefully
back. As with dogs in
countless European
portraits of couples from
before and after this,
the dog is the image's
symbol of marital loyalty.

negative. In the Book of Revelation (22:15) they are grouped with the unclean and benighted: 'Outside are the dogs and sorcerers and the sexually immoral and murderers and idolaters, and everyone who loves and practises falsehood.' Therefore dogs can be symbols of the highest and the lowest orders of life.

Veronese's *Happy Union* – probably painted in Venice in around 1575 – shows a dog in its more positive guise as a symbol of faithfulness. It comes from a series of four paintings, now known as the *Allegories of Love*, which is believed to show allegories of four facets of romance: *Unfaithfulness*, *Scorn*, *Respect* and *Happy Union*. Each one uses iconography taken from Renaissance books of emblems, known as *emblemata*. In Andrea Alciato's version of 1531, the emblem of 'faithfulness in a wife' features a puppy at the feet of the couple, channelling the Greco-Roman attitudes towards dogs as a symbol of fidelity.

Veronese had clearly consulted an *emblemata* when painting *Happy Union*, as it contains a range of allegorical motifs. It appears to represent the ideal of marriage as a dignifying and auspicious covenant: the figure of *Fortuna* (good fortune) dominates the proceedings, sitting on a sphere representing the world, and beside a cornucopia (a 'horn of plenty'). She crowns the devoted couple with a myrtle **crown** of luck and hands them an olive branch of peace.

For Veronese, who was as interested in observing and depicting real life as he was in the abstractions of iconography, the dog is more than an emblem, simultaneously behaving as a real dog would, gazing at the venerated olive branch as if only to see a prospective quarry in a game of fetch.

KEY ARTWORKS

Mechanical dog (Egypt), c.1390–1353 BCE, Metropolitan Museum of Art, New York, NY, USA

Piero di Cosimo, *A Satyr Mourning over a Nymph*, c.1495, National Gallery, London, UK

Xolotl (Aztec), from the *Codex Borgia*, p.65, c.1500, Vatican collections, Vatican City, Rome, Italy

Sir Anthony Van Dyck, *The Five Eldest Children of Charles I*, 1637, Royal Collection, UK

Artist unknown
Cave Canem (*Beware of the Dog*), Casa di Orfeo, Pompeii, 1st century BCE
Mosaic, 70 x 70 cm (27½ x 27½ in.)
Museo Archeologico Nazionale, Naples

Not all societies are fond of dogs, but the Romans kept them as pets and they were treated as family members as well as guardians of the household. This mosaic was created for the floor of an entrance to the Casa di Orfeo in Pompeii.

FISH

Fish featured in the ancient religions in Mesopotamia and Egypt as symbols of fertility and regeneration, alongside **seashells** and **water**. Fish feature heavily in the Christian Bible, most famously in the parable of the loaves and fishes, and are also associated with the rebirthing ceremony of baptism. The fish-shaped *ichthys* symbol has therefore become a logo for Christians.

The fantastical and calamitous story of *Jonah and the Whale* similarly connects fish and rebirth. The story appears in the Hebrew Bible, the Christian Old Testament and also the Qur'an. Jonah is said to have been swallowed by a giant fish (which is sometimes translated as 'whale') after having disobeyed the word of God. For three days and three nights Jonah survived inside the fish before God answered his prayers for forgiveness and the fish vomited him onto a nearby shore. This is usually interpreted as a story of redemption and spiritual rejuvenation: Jonah had now become a faithful servant of God. In the painting the words 'THE SUN'S DISK WENT INTO DARKNESS, JONAH WENT INTO THE MOUTH OF A FISH' are emblazoned across Jonah's arms like a tattoo. The narrative details of *Jonah and the Whale* were probably taken from a compendium of world stories known as the *Jami' al-tawarikh*, written by Rashid al-Din Hamadani, a scholar of the

Artist unknown
Jonah and the Whale,
folio from the *Jami' al-tawarikh* (*Compendium of Chronicles*), c.1400
Ink, opaque watercolour and gold, 33.7 x 49.5 cm
(13¼ x 19½ in.)
Metropolitan Museum of Art, New York

In this painting, Jonah is a grateful recipient of a set of clothes from the angel that swoops in from above.

Il-Khanid court in Tabriz (now in Iran). However, its stylistic qualities point to international influences. Jonah's fish is represented as a carp which is a popular emblem in China (where its associations were with wealth and persistence), much like the **dragons** and **phoenixes** that also appear in Iranian art at this time. Trading routes in operation across Eurasia were exchanging more than merchandise – they were also transacting the language of symbols.

KEY ARTWORKS

The Adda Seal (Mesopotamia), 2300 BCE, British Museum, London, UK

Masaccio, *The Tribute Money*, c.1424–7, Brancacci Chapel, Santa Maria del Carmine, Florence, Italy

Diego Velázquez, *Christ in the House of Martha and Mary*, probably 1618, National Gallery, London, UK

Gong Gu, *Carp* (China), 19th century, Metropolitan Museum of Art, New York, NY, USA

LION

Among the many symbolic uses of lions throughout history, the most common are as a guardian and as a symbol of authority. Sculptures of lions stood at the entrances of temples in Mesopotamia and Egypt, and King Ashurbanipal of Neo-Assyria ordered extensive relief sculptures detailing his ability to hunt them (see the *Hunting Lions* relief on page 140). Lions were fundamental to the iconography of many faiths including the ancient religion of Mithraism, and they featured often as vengeful beasts in Hinduism. In the Bible, lions are mentioned frequently and they act as attributes for numerous saints including St Mark. They also became a key motif in the visual art of Buddhism, as exemplified by the Ashokan Pillar's lion capital. The spread of this religion over the course of the first millennium took the lion motif east and into Chinese iconography, from where it once again disseminated as an increasingly stylized motif to the rest of eastern Asia.

The lion capital of the Ashokan Pillar comes from Sarnath in India, a **deer** park and the site of Buddha's first sermon. There he proclaimed the Four Noble Truths that he had apprehended while meditating: the truth of suffering, the truth of the origin of suffering, the truth of the ending of suffering and the truth of the path to the ending of suffering. The lion capital once sat at the top of a pillar that had been installed by Ashoka, the Indian emperor and a convert to Buddhism. It holds great significance to the national identity of India.

The four lions are intended to be a symbol of courage and power; they symbolize Buddha and may also be an emblem of Ashoka. Beneath the lions are more symbols: four animals (lion, ox, elephant and **horse**) turning the dharmachakras (the wheels of dharma). At the base of the capital is a **lotus** flower. The capital was adopted as the national symbol of India in 1950, and the twenty-four-spoke dharmachakra is placed at the centre of the Indian flag.

Artist unknown
Lion capital, Ashokan Pillar at Sarnath, c.250 BCE
Polished sandstone, 210 x 283 cm (82¾ x 111½ in.)
Archaeological Museum Sarnath, near Varanasi

The lions' mouths are open to represent the broadcasting of the Buddha's Four Noble Truths towards the four points of the compass.

KEY ARTWORKS

Ren Keli, *The Lion and his Keeper* (China), 1480–1500, British Museum, London, UK

Albrecht Dürer, *Saint Jerome*, c.1496, National Gallery, London, UK

Titian, *Allegory of Prudence*, c.1550–65, National Gallery, London, UK

Henri Rousseau, *The Repast of the Lion*, c.1907, Metropolitan Museum of Art, New York, NY, USA

MONKEY

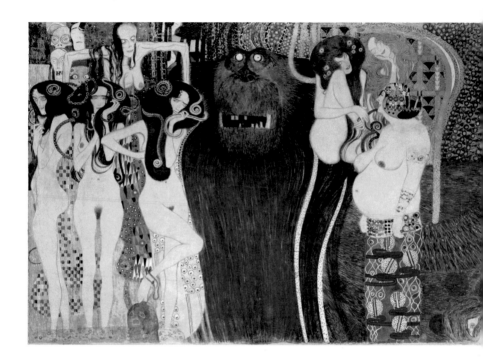

In many cultures from across the globe, including those of the
Aztecs, Japan and China, monkeys are tricksters and symbols of
mischief. In Hinduism the monkey god Hanuman is an esteemed
member of the pantheon, but in western art the monkeys are
frequently shown in a negative light, as allegories of mimicry, vanity
or lust. One such example is the central scene in Gustav Klimt's
Beethoven Frieze, where a monkey is a symbol of the very lowest and
most depraved of human vices.

In its totality the *Beethoven Frieze* is a homage to the highest
of human achievement: the music of Ludwig van Beethoven.
It is a visual summation of the composer's work and part of a
Gesamtkunstwerk – a total work of art that was intended to
incorporate architecture, music, painting and sculpture into a single
unified experience. It repurposed motifs from folklore and classical
mythology to depict an allegorical narrative of humanity journeying

Gustav Klimt
Beethoven Frieze, 1901–2
Gold, graphite and casein
paint, 215 x 3400 cm
(84¾ x 1338½ in.)
Secession Building,
Vienna

**The ape in Klimt's
painting was intended
to symbolize the dark
and evil desires of the
human soul.**

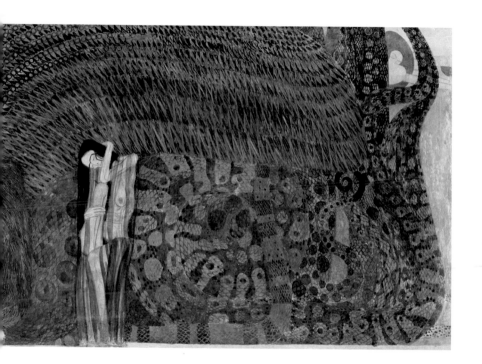

from suffering to enlightenment, under the protection of a questing knight. When it was unveiled in Vienna in 1902, visitors could purchase a catalogue that explained all the symbols that appeared in the painting. The central scene, which represented various base human instincts that needed to be overcome by the noble spirit, was explained thus:

> Narrow wall: the Hostile Powers. The giant Typhon, against whom even the gods fought in vain; his daughters, the three Gorgons. Disease, insanity and death. Debauchery and unchastity, intemperance. Gnawing Worry. The longings and desires of humankind fly away over these.

Typhon is depicted as a gigantic ape, with the Gorgons, Death, Disease and Insanity on the left and the other figures on the right.

Typhon was a monster from Greco-Roman mythology, but was usually depicted as a serpent or **snake**. Klimt's decision to create a simian version may have been a response to the evolutionary theories of Charles Darwin, published in *The Origin of the Species* in 1859, and the understanding that the boundary between human and animal could no longer be considered absolute or clear-cut.

African Adventure was originally commissioned as a site-specific installation for an ex-British Officer's Mess in Cape Town, and its title is taken from a South African travel agency. It is itself a warped holiday into South African identity. Alexander's work does not correspond to iconographic traditions relating to animals in art history, and her disorientating visual language serves to reflect the topsy-turvy ethics and brutishness of South Africa's colonial and apartheid history.

KEY ARTWORKS

Hanuman Conversing (India), 11th century, Metropolitan Museum of Art, New York, NY, USA

Paolo Veronese, *The Family of Darius before Alexander*, 1565–7, National Gallery, London, UK

Frida Kahlo, *Self-portrait with Monkey*, 1938, Albright–Knox Art Gallery, Buffalo, New York, NY, USA

Guerrilla Girls, *Do women have to be naked to get into the Met. Museum?*, 1989, posters can be found at Tate, London, UK, and in collections worldwide

Jane Alexander
African Adventure,
1999–2002
Mixed media and bush
sand, c.400 x 900 cm
(157½ x 354⅜ in.)
Tate, London

In this looking-glass
world, the denizens are
mutants – some of whom
have been given names by
Alexander. The foremost
is the sinister and
confrontational monkey-
headed 'Harbinger'.

SNAKE

For many of the symbols in this book meanings change with context; a motif can signify a particular quality in one culture and the opposite in another. This is epitomized brilliantly by snake imagery in global visual culture. In different places and at different time snakes have been variously a symbol of eternity, the underworld, divination, health, death, regeneration, sin, fecundity, protection, kingship, divinity and the devil.

The British Museum's *Double-headed Serpent* is probably a representation of an Aztec snake-god called Quetzalcoatl. In Aztec culture snakes were an object of fascination. The fact that they periodically shed their skin earned them an association with renewal and fertility, and their ability to live on earth and in the water suggested a mystical, boundary-transgressing power. Their hybrid status was elaborated in the belief that Quetzalcoatl also possessed avian qualities linking it to the sky, and was therefore represented in painting and sculpture as a feathered serpent.

In Christianity a snake generally represents the serpent who tempted Eve to eat the fruit of knowledge in the Garden of Eden, and is thus a symbol of sin and Satan. A 1900 poster for Dr Abreu's sanatorium in Barcelona draws upon this imagery to reach sufferers of syphilis, which was endemic and not successfully treatable in Europe at the time. The advertisement's *femme fatale* – a none-too-subtle allegory for the sexually transmitted disease – holds a **lily** of purity outwards, but conceals a snake behind her ragged shawl. Even the lettering above is formed out of serpent-shaped letters.

Artist unknown
Double-headed Serpent (Mexico), c.15th–16th century
Cedrela wood, turquoise, pine resin, oyster shell, hematite and copal, 20.5 x 43.3 x 6.5 cm (8 x 17 x 2½ in.)
British Museum, London

The tiny pieces of bevelled, tessellated turquoise on the *Double-headed Serpent* were polished to replicate the colour of the sky as well as the appearance of scales. It is possible that it was worn around the neck as a pectoral by a priest or ruler.

KEY ARTWORKS

Athanadoros, Hagesandros and Polydoros of Rhodes, *Laocoön and his Sons*, early 1st century CE, Vatican Museums, Vatican City, Rome, Italy

Lucas Cranach the Elder, *Adam and Eve*, 1526, The Courtauld Gallery, London, UK

Caravaggio, *Medusa*, 1597, Uffizi Gallery, Florence, Italy

Giovanni Battista Tiepolo, *The Immaculate Conception*, 1767–9, Prado, Madrid, Spain

R. Casas
Advertisement for
Dr Abreu's Sanatorium
for Syphilitics in
Barcelona, c.1900
Colour lithograph,
66.3 x 28.2 cm
(26⅛ x 11⅛ in.)
Wellcome Collection,
London

**Snakes as symbols
of evil abound in
Christian art. Here this
conventional association
is used in a different
context to imply the
malevolence of sexually
transmitted disease.**

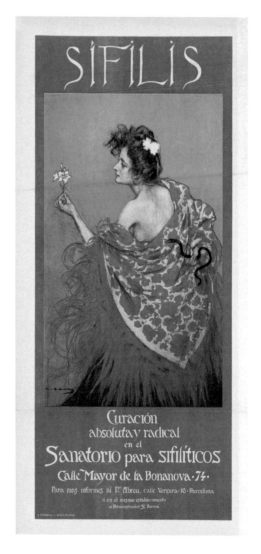

HORSE

Horses are thought to have been first domesticated by humans on the steppes of Ukraine and Kazakhstan at some point between 4500 and 3500 BCE. The ability to ride horses revolutionized humanity's capacity to travel at speed, herd livestock, transport goods, hunt and fight. This probably accounts for the horse's innate prestige and symbolic power in art. Semi-divine steeds featured in the *Rigveda* (an Indian book dating from around 1500 BCE that captures the earliest recorded religious stories), and horses were venerated in many subsequent mythologies including those of Celtic, Norse and Greco-Roman cultures. They have been equated with high social status, military valour and sporting triumph ever since.

In 1800 Napoleon Bonaparte, recently created first consul of France, led his army across the Alps so that he could engage the Austrian army at the Battle of Marengo. The French victory and Napoleon's leadership were celebrated one year later in a large-scale portrait painted by Jacques-Louis David. But the conception was not wholly the artist's, as Napoleon himself had requested that he be shown 'calm on a fiery horse' – leading his troops to their glorious destiny, rather than mid battle.

The choice of an equestrian portrait had significant symbolic meaning. Countless heroes and leaders from antiquity, such as Alexander the Great and Marcus Aurelius, had been shown astride a horse to demonstrate their powers of control: the irrepressible force tamed by the immovable ruler. In Napoleon's day thoroughbred horses were still considered prestigious diplomatic gifts to be proffered between the leaders of nations.

Jacques-Louis David
*Napoleon Crossing
the Alps*, 1800–1
Oil on canvas,
261 x 221 cm
(102¾ x 87 in.)
Kunsthistorisches
Museum, Vienna

In David's painting,
Napoleon's steed is a coil of
wild energy, totally under the
command of its self-assured
rider who spurs his men
onwards to their eminent
destinies. In historical fact,
this episode did not occur:
Napoleon did cross the Alps
in 1800, but he did so to the
rear of his army, riding on
a mule.

In an Asian context, and over a millennium before, *Night-shining White* delivers a remarkably similar message – although the subject of this portrait is the horse, not the rider. Xuanzong of China (685– 762 CE), the longest-reigning of the Tang emperors, was devoted to his war-horses, imported from far-flung Arabia and Central Asia; Night-shining White was his favourite. These horses' superiority to the smaller and weaker local ponies made them symbols of elite power, and of the exotic wonders to be found at the edges of the known world, thanks to China's international trading reach. They inspired not just paintings, but sculptures and even poems in their honour, commissioned by impressed members of the Chinese elite.

KEY ARTWORKS

Attributed to Phidias, Parthenon Frieze, 438–432 BCE, British
 Museum, London, UK
Equestrian Oba and Attendants plaque (Court of Benin, Nigeria),
 1550–1680, Metropolitan Museum of Art, New York, NY, USA
George Stubbs, *Whistlejacket*, c.1762, National Gallery,
 London, UK
Wassily Kandinsky, *Blue Mountain* (*Der blaue Berg*), 1908–9,
 Guggenheim Museum, New York, NY, USA

Han Gan
Night-shining White,
handscroll, c.750 CE
Ink on paper,
30.8 x 34 cm
(12⅛ x 13⅜ in.)
Metropolitan Museum
of Art, New York

It was believed that these imported war horses particularly embodied the yang (masculine) principle and symbolized the latent dynamism of nature. As a result a mythology grew that they were dragons in disguise, and that they sweated blood.

DRAGON

Dragons have long been a pervasive symbol in China. They featured in ancient Chinese art, but their most recognizable form (well presented on the Chinese emperor's robe on page 28) was established around the first century BCE, quite possibly adapted from imagery brought to China from the steppe tribes during the first millennium BCE. Over time the mythical beast became associated with the sky, rain-bearing **clouds** and auspicious supernatural events. One of these, described in Chinese historical records from the first century BCE, is of the birth of Gaozu, one of the most distinguished of China's emperors and founder of the Han dynasty. Gaozu's mother, according to the text:

> was one day resting on the bank of a large pond when she dreamed that she encountered a god. At this time, the sky grew dark and was filled with thunder and lightning. When Gaozu's father went to look for her, he saw a scaly dragon over the place where she was lying. After this she became pregnant and gave birth to Gaozu.

Dragons also feature within Chinese cosmology (different from the Buddhist cosmology in the *Cosmological Mandala of Mount Meru* on page 49). The four cardinal points of the compass include the azure dragon associated with the east. At the centre (the fifth cardinal point) is the yellow dragon, and hence its association with the emperor himself. It is the emperor's personal symbol, the empress's being the **phoenix**. The emperor's dragon is distinguished by having five claws on its feet, rather than the three or four that

Qasim ibn 'Ali
Isfandiyar's Third Course: He Slays a Dragon, folio from the *Shahnama* of Shah Tahmasp (*Book of Kings*), c.1530
Opaque watercolour, ink, silver and gold on paper, 27.9 x 26.2 cm, (11 x 10¾ in.)
Metropolitan Museum of Art, New York

Painted in the Safavid court in Iran, this image contains a dragon that has been influenced by the style of Chinese art, even though it lacks the benevolence normally associated with dragons from the east.

featured on the insignia of lesser members of court. Like the **horse** it represents yang (masculine power) and is frequently represented alongside a **phoenix** (yin, feminine power) to demonstrate balance.

Chinese-style dragons, with their overtones of imperial authority and wealth, eventually spread into the symbolic language of neighbouring territories, including Korea and Japan.

During the Yuan dynasty (1271–1368), trade routes transmitting and receiving goods between China and the rest of Asia were firmly established. As a result Iran's visual culture began to incorporate Chinese motifs, as can be seen in *Jonah and the Whale* on page 93, and in *Isfandiyar's Third Course: He Slays a Dragon*, an episode from the Iranian epic the *Shahnama*. Here we have the third of seven challenges that Prince Isfandiyar has to undertake: slaying a malevolent dragon by jousting it from within a box-mounted chariot. The fanged dragon, rippling with yang energy, may be influenced by examples seen on Chinese porcelain or painting, but the character of the dragon is quite different – in the context of the *Shahnama* it has become a symbol of evil.

In Christianity the dragon (like the **snake**) is also a symbol of sin and of Satan himself. It is common to see dragons being exterminated by St George and the Archangel Michael in allegorical scenes of evil submitting to virtue. In earlier, Greco-Roman myth Perseus too was a dragon-slayer, and a possible source of influence for the later Christian saints.

William Blake's *The Great Red Dragon and the Woman Clothed with the Sun* is a scene from the biblical Book of Revelation and it inventively gives us the dragon's perspective on events. Blake's monster owes a greater debt to medieval European representations of dragons (albeit grafted onto a muscular, Michelangelo-inspired torso), which are essentially demons with wings and horns, as in Bartolomé Bermejo's *Saint Michael Triumphs over the Devil* (page 153).

William Blake
The Great Red Dragon and the Woman Clothed with the Sun (Rev. 12:1–4), c.1803–5
Black ink and watercolour over traces of graphite and incised lines,
43.7 x 34.8 cm
(17¼ x 13¾ in.)
Brooklyn Museum of Art, New York

This painting demonstrates Blake's artistic nonconformity: in this period artists generally avoided representing the bizarre events of St John's Book of Revelation (as Blake has done), choosing instead to show its author in the act of writing it.

KEY ARTWORKS

Paolo Uccello, *St George and the Dragon*, c.1470, National Gallery, London, UK

Solomon Enthroned and Surrounded by his Court (Islam), late 18th century, British Museum, London, UK

Utagawa Kuniyoshi, *Tamatori Escaping from the Dragon King* (Japan), mid-19th century, British Museum, London, UK

Sir Edward Burne-Jones, *The Doom Fulfilled*, 1888, Southampton City Art Gallery, Southampton, UK

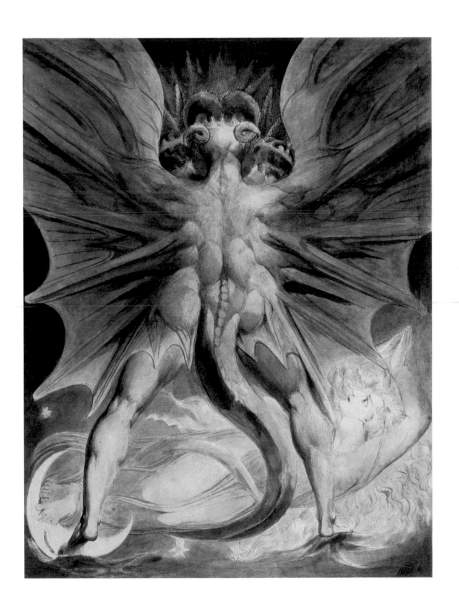

BODIES

-

We are symbols, and inhabit symbols

-

Ralph Waldo Emerson
1844

SKELETON

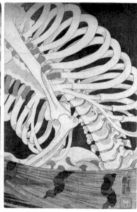

Utagawa Kuniyoshi probably saw the tale of *Mitsukuni Defying the Skeleton-Spectre* being acted out in a kabuki play in 1844. Its story, adapted from a Japanese novel published in 1807, is as follows: As a consequence of a rebellion against his rule in 939 CE, the Japanese emperor ordered a warrior named Ōya no Mitsukuni to track down and execute any remaining conspirators. Mitsukuni travelled to the palace of Sōma, the refuge of the rebel chief's daughter, Princess Takiyasha. Unbeknown to Mitsukuni however, the princess had been taught magic by a local hermit. Reading a spell from an ancient scroll, she summoned the ghosts of the rebels and melded them into a giant skeleton to fight the dauntless and ultimately victorious Mitsukuni.

While the motif of a skeleton may seem like an ageless and universal symbol of mortality and the macabre, they did not in fact appear fully in Japanese visual culture until the eighteenth century. It is possible that they did so only after Dutch traders had introduced European medical books with their detailed anatomical drawings of cadavers to the country.

Despite their much earlier use as symbols in Indian art, skeletons only appeared in European art during the late medieval period to represent death, most notably in Dance of Death scenes in which

Utagawa Kuniyoshi
Mitsukuni Defying the Skeleton-Spectre (Japan), c.1845
Colour woodblock triptych print on paper, 35.9 x 74.2 cm (14⅛ x 29⅛ in.)
Fine Arts Museum of San Francisco, San Francisco

In Utagawa Kuniyoshi's *Mitsukuni Defying the Skeleton-Spectre*, created in Japan, the skeleton fulfils its familiar role as harbinger of death. Kuniyoshi's detailed and anatomically realistic representation of a skeleton appears to have been inspired by scientific diagrams found in European medical texts.

skeletons cavort with citizens and take them to their graves. They also feature heavily in Mexican Day of the Dead festivities when the souls of the dead are supposed to join the living.

What the Water Gave Me by the Mexican artist Frida Kahlo features a lonely skeleton sitting on an island beside a volcano (among a large number of other insects, plants, people and animals) in the lower part of the artist's bathtub. While probably alluding to the Day of the Dead, and the popularized skeleton images of José Guadalupe Posada, the skeleton may also refer to the more ancient Aztec skeleton gods and goddesses such as Mictlāntēuctli and Ītzpāpālōtl, and the skeletal folk-Catholic Santa Muerte. In Aztec iconography the skeleton was intimidating and symbolized destruction, but predominantly as a positive force to suggest that life would be impossible without the purging energy of death.

Frida Kahlo
What the Water Gave Me, 1938
Oil on canvas,
91 x 70 cm
(36 x 27¾ in.)
Collection of Daniel
Filipacchi, Paris

Skeletons recur in Kahlo's work as a symbol of Mexico, alongside other motifs from Aztec culture, and numerous other symbols, ranging from animals and plants to blood, that refer to her personal cultural, political and feminine experiences.

KEY ARTWORKS

Hieronymus Bosch, *Death and the Miser*, c.1485–90, National
 Gallery, Washington, DC, USA
Hans Holbein, *The Dance of Death*, 1523–5, Rijksmuseum,
 Amsterdam, Netherlands
José Guadalupe Posada, *Calavera of a Soldier from Oaxaca*, 1903,
 broadsheet, Collection A. V. Arroyo, Mexico City, Mexico
Paul Delvaux, *Sleeping Venus*, 1944, Tate, London, UK

SKULL

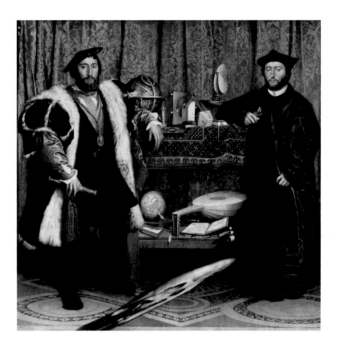

From the half-obscured crucifix at its top left-hand corner to the snapped string on the yellow lute, Hans Holbein's *The Ambassadors* (painted in London) is a painting with an unusually broad range of symbolic details. Why the artist has included so many cryptic motifs is a mystery and one that leads to other probably unanswerable questions about the reason for the commission, and the relationship between the men. Perhaps Jean de Dinteville (standing on the left), who commissioned the portrait, worked in collaboration with his friend Georges de Selve (on the right) as well as Holbein to create an image that would overwhelm the viewer with symbols of their extensive intellectual interests. The most renowned of the symbols is the oblong shape at the bottom of the painting – a human skull rendered in anamorphic perspective: only visible if you view it from the upper right-hand side, at an oblique downward angle.

Holbein had previously used skeletons and skulls extensively in his uproarious and macabre series of forty-one woodblock prints called *The Dance of Death*, where skeletons are malevolent death-bringers preying indiscriminately on victims from across the social spectrum, from emperors and monks to farmers.

Hans Holbein the Younger
The Ambassadors, 1533
Oil on oak,
207 x 209.5 cm
(81½ x 82½ in.)
National Gallery, London

The fact that the skull is painted in anamorphic perspective is a philosophical point as much as an optical trick – death is an ungraspable reality that underpins life, and neither condition can be grasped clearly at the same time.

Artist unknown
*Chamunda, the Horrific
Destroyer of Evil* (India),
10th–11th century
Sandstone, height
113 cm (44½ in.)
Metropolitan Museum
of Art, New York

**Chamunda, the vengeful
version of the protective
and maternal Hindu
goddess Durga, wears
a tiara decorated with
skulls and a crescent
moon. Sculptures such
as this one were designed
for the exterior walls
of a temple; rather
than being an object
of fear, however, she
was intended to restore
harmony by fighting
evil demons.**

In *The Ambassadors*, the symbolism is more passive: the skull is a *memento mori* – a reminder of the ubiquity of death and the brevity of life. The way Holbein uses a skull symbol is broadly characteristic of Christian art and European still-life painting; it is often an object of contemplation about mortality, and is an attribute of certain meditative religious figures such as St Francis of Assisi and Mary Magdalene. Skulls are given a less benign purpose in some Tibetan Buddhist and Hindu religious art where deities wear skulls as part of their regalia, sometimes using them as blood-filled cups.

KEY ARTWORKS

Mosaic with Skull and Level, summer triclinium of the House 1, 5, 2 in Pompeii, 1st century CE, National Archaeological Museum, Naples, Italy

Frans Hals, *Young Man Holding a Skull (Vanitas)*, 1626–8, National Gallery, London, UK

Georgia O'Keeffe, *Cow's Skull: Red, White, and Blue*, 1931, Metropolitan Museum of Art, New York, NY, USA

Damien Hirst, *For the Love of God*, 2007, private collection

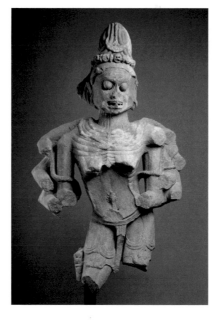

FOOT

The presence of feet has divergent meanings in eastern and
western art. In Hindu and Buddhist art a footprint is considered
holy, as it marks the imprint of a deity and their interaction with
the earth. In Christianity a depiction of an exposed foot normally
indicates the humility of the poor.

Footprints of the Buddha (Buddhapada) shows an early adoption
of a technique previously used in Hindu worship to make a footprint
a site of worship. It marks a spot where the Buddha was supposed
to have walked, and allowed worshippers to experience his presence
and absence simultaneously.

According to the Bible, Jesus bathed the feet of his disciples and
in doing so demonstrated his charity and humility. Responding to
this story, Niccolò Lorini del Monte, a seventeenth-century Italian
scholar, declared in 1617 that 'feet may be taken by the holy church
as symbolizing the poor and humble . . . feet are the last and most
lowly part of the human body, the poor and humble are the last

Artist unknown
*Footprints of the
Buddha (Buddhapada)*,
2nd century CE
Schist, 86.36 x
125.1 x 6.35 cm
(34 x 49¼ x 2½ in.)
Yale University Art
Gallery, Yale

**In this work each foot has
two dharmachakras with
a lotus flower at their
centre, a triratna symbol,
and swastikas and trident
motifs decorating the
toes. Similar footprints
can be found in Sri
Lanka, Thailand, China
and Japan.**

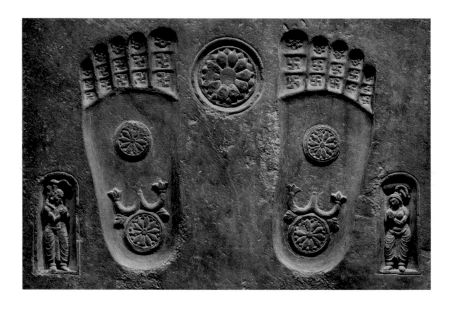

Caravaggio
Madonna di Loreto,
1604–6
Oil on canvas,
260 x 150 cm
(102 x 59 in.)
Church of Sant'Agostino,
Rome

Such unmitigated, gritty realism, as shown in the bare feet, in the context of a religious image was a radical move in the early seventeenth century. It glorified the poor and was intended to inspire the wealthy to fulfil their charitable duty towards the underprivileged.

part, and those who hold the last place in the church'. Caravaggio's *Madonna di Loreto* was painted in Rome shortly before this statement was written and shows two pilgrims witnessing a vision of the Madonna. The artist has made their careworn feet a focal point, forcing his audience to contemplate the church's responsibility for the lowest in society.

KEY ARTWORKS

Lo Spinario, 1st century BCE, Palazzo dei Conservatori, Musei
 Capitolini, Rome, Italy
Andrea Mantegna, *Dead Christ,* c.1480–1500, Pinacoteca di Brera,
 Milan, Italy
Reclining Buddha, 1832, Wat Pho, Bangkok, Thailand
Ford Madox Brown, *Jesus Washing Peter's Feet,* 1852–6,
 Tate, London, UK

POSE

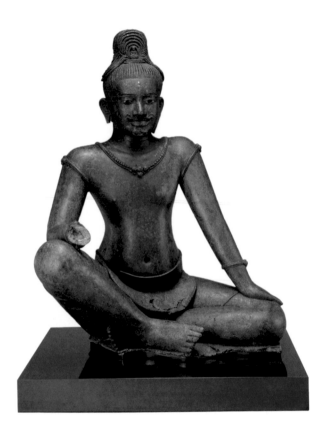

In western art the poses of human bodies normally carry some
kind of significance. But given the sheer range of bodily gestures
a person can make (and the huge variety of ways they might be
interpreted depending on their social and cultural context), it is
often hard to be categorical about specific meanings.
However, in the religious art, dance and meditation of South-
East Asia, postures (*asanas*) have been codified and carry set
meanings. When incorporated into the discipline of yoga, these
poses are believed to enhance spiritual experiences by creating ideal
receptivity to meditation.

One example from this canon of poses, gestures and facial
expressions is known as *rajalilasana*, translatable as 'royal ease'.

118

Artist unknown
The Bodhisattva Avalokiteshvara Seated in Royal Ease (Cambodia), 10th–11th century
Copper alloy and silver inlay, 57.8 x 45.7 x 30.5 cm (22¾ x 18 x 12 in.)
Metropolitan Museum of Art, New York

This posture breaks with the rigidity of the typical flat cross-legged lotus pose reserved for the Buddha, making Avalokiteshvara seem mobile and responsive both to his environment and his mortal audience.

It is a cross-legged pose with one knee raised for comfort and is demonstrated by the figure in *Bodhisattva Avalokiteshvara*. The work depicts the bodhisattva of compassion and mercy in a particularly sinuous and serene way. Black-glass inlays were once fixed in the place of his moustache, eyes and eyebrows, which must have bestowed on his face a shimmering lustre to complement the gentle authority of his facial expression. But his pose was probably the aspect that carried the greatest symbolic weight for his original audience. By sharing a royal pose, it also reminds us that kings were linked with the divine in Khymer culture, suggesting that this example may even represent a specific Khymer ruler who embodied the grace of a bodhisattva. Other examples of *asanas* include: the lotus position (*padmasana* – seated with the legs crossed and soles of the feet upward) and the posture of relaxation (*lalitasana* – like the lotus pose but with one leg dangling down).

In European art it is possible to identify some characteristic poses. Contrapposto is a frontal pose with one leg bent to cause the hips to tilt (as you can see for example in Mercury in Botticelli's *Primavera* on pages 18–19). Adlocutio is where a figure has an outstretched arm signifying a leader addressing his troops (represented in David's *Napoleon Crossing the Alps* on page 103).

Grayson Perry's *The Adoration of the Cage Fighters* is part of a series of tapestries that document an imagined twenty-first-century citizen called Tim and his odyssey through the English class system. Each one riffs on themes from art history, adopting and adapting poses, symbols and compositions from recognizable precursors in the western canon. Here Perry openly parodies religious paintings, such as Andrea Mantegna's *The Adoration of the Shepherds* (c.1450), with two martial arts fighters in a kneeling pose of veneration known as genuflection. They do so in front of Tim's uninterested mother, proffering gifts with a significance to their local Sunderland – a baby-sized Sunderland Football Club kit and a miner's lamp.

KEY ARTWORKS

Adlocutio – *Augustus of Primaporta*, 1st century CE, Vatican Museums, Vatican City, Rome, Italy

Lalitasana – Enthroned Vishnu, second half of the 8th–early 9th century, Metropolitan Museum of Art, New York, NY, USA

Padmasana – Seated Amitabha Buddha (*Amida Nyorai*), c.794–1185, Asian Art Museum, San Francisco, CA, USA

Contrapposto – Michelangelo, *David*, 1501–4, Galleria dell'Accademia, Florence, Italy

Grayson Perry
*The Adoration of the
Cage Fighters*, 2012
Wool, cotton, acrylic,
polyester and silk tapestry,
200 x 400 cm
(78¾ x 157½ in.)
Arts Council Collection,
London

Symbols proliferate in
Grayson Perry's tapestry
to show us the multiple
layers of identity at
play in contemporary
Britain. Many are related
to popular culture,
but the composition is
inspired by a Renaissance
altarpiece, indicating the
enduring influence of
certain historical symbols
and poses.

HAND GESTURES

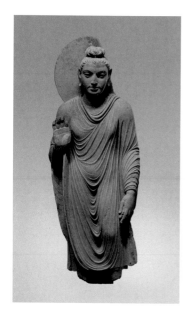

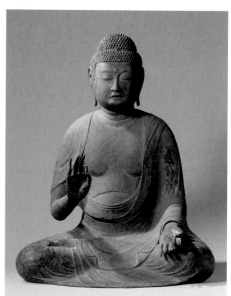

In Hindu and Buddhist art the hand gestures of a deity, known as *mudras*, symbolize religious meaning. As with *asanas* (bodily **poses**) these were codified during the course of the first millennium CE in Asia, possibly by adapting them from the postures of ritual dance. An early example of the establishment of this language is the Gandhara *Standing Buddha* whose right hand is raised with palm outwards in a gesture known as *abhaya-mudra*, a sign of divine protection and the removal of all fear. In later sculptures this gesture would be combined with a downward-facing open left hand to signify the granting of a wish in a gesture known as *varada-mudra* (visible on the sixth-century Chinese sculpture of *Buddha Maitreya* on page 134 and the *Shiva Nataraja* on page 33). The twelfth-century Japanese *Buddha Amida* sits in the *padmasana* pose with both hands in what is known as the *vitarka-mudra* which indicates teaching, the connected tips of his thumb and forefinger creating a wheel as in the 'Wheel of the Law' (*dharmachakra*).

Above, left:
Artist unknown
Standing Buddha
(ancient region of
Gandhara, now in
Pakistan),
c.2nd century CE
Schist, height
119.7 cm (47⅛ in.)
Cleveland Museum of
Art, Cleveland

In the *abhaya-mudra*
gesture, the raised
right hand conveys the
granting of contentment
and security to
worshippers.

In European art it would be possible to specify innumerable hand gestures, some more easily interpreted than others. However, a common one is the sign of blessing, where only the thumb, index finger and middle finger are extended, symbolizing the Trinity of Father, Son and Holy Ghost. Tilman Riemenschneider's *A Bishop Saint* is believed to depict an English bishop of Würzburg who had died in 754. The hand gesture that extends outwards towards the faithful spectator is as effective in bringing the figure to life as is the extraordinarily sensitive and highly naturalistic rendition of the man's facial features.

Opposite, right:
Artist unknown
The Buddha Amida
(Japan), c.1125–c.1175
Wood, 87 x 71 x 56.5 cm
(34⅜ x 28 x 22¼ in.)
Rijksmuseum,
Amsterdam

The touching of the tips of thumb and forefinger to make a circle is known as *vitarka-mudra*. It is a gesture of teaching and symbolizes the Buddhist 'Wheel of the Law'.

KEY ARTWORKS

Sultanganj Buddha, c.500–700, Birmingham Museum and Art
 Gallery, Birmingham, UK
Seated Buddha (Gandhara, now in Pakistan), 1st–mid-2nd
 century, Metropolitan Museum of Art, New York, NY, USA
Buddha Expounding the Dharma (Anuradhapura, Sri Lanka), late
 8th century, Metropolitan Museum of Art, New York, NY, USA
Christ Pantocrator mosaic, 12th century, Hagia Sophia,
 Istanbul, Turkey

Tilman Riemenschneider
A Bishop Saint (Burchard of Würzburg?), c.1515–20
Linden wood with traces of polychromy, 82.3 x 47.2 x 30.2 cm (32⅜ x 18½ x 11⅞ in.)
National Gallery of Art, Washington, DC

The sign of blessing (where thumb, index finger and middle finger are extended) is offered by the clergy in Christian worship.

BLOOD

Blood is a symbol of vitality in cultures from around the world. Ceremonies involving blood-letting and ritual anointing with blood (for example, daubing votive sculptures with blood) are features of Greco-Roman, Mithraic, Hindu, Mayan, early Jewish and West African Vodun religions. Blood was also key to Mayan and Aztec ritual and art. In Aztec belief, humanity was created by the gods letting their own blood, and so they had to be repaid in kind by a 'blood debt', in the form of mass human sacrifices. In western culture blood has had symbolic associations with such concepts as sacrifice and individual authenticity in the form of family lineage (one's bloodline) and contractual obligation (the 'blood oath'). The blood of Jesus is one of the most powerful Christian symbols, and it is invoked during the rite of the Eucharist in order to signify redemption. Blood is often depicted in images of the crucifixion, sometimes in great quantities, and at others with **angels** catching it in cups.

Marc Quinn's *Self* consists of ten pints of the artist's blood, withdrawn from his body over five sessions, frozen in a plaster cast of his head and preserved in a refrigerated Perspex unit as an electricity-dependent version of an antique bust. It is a response to a perennial issue facing portraitists through history: how to make the sitter seem genuinely present in an otherwise static and inert art object. The use of blood as a token of authenticity, vitality and martyrdom therefore links Quinn to a deeper history of artistic and religious symbolism.

Marc Quinn
Self, 2006
Ten pints of blood
(artist's), stainless
steel, Perspex and
refrigeration equipment,
208 x 63 x 63 cm
(81⅞ x 24¾ x 24¾ in.)
Private collection

In Quinn's innovative
sculpture the artwork is
the artist, made from his
own blood. The history
of culture is replete with
tales of self-sacrifice
in the name of art, but
few with as much daring
as this.

In the nineteenth-century image of Chinnamastā (opposite) sex and death have been boldly desegregated. The central figure, a malevolent version of the mother goddess Devi, is shown in the aftermath of a self-decapitation, still standing upon the bodies of two other deities, Rati and Kama, who are busily copulating in a **lotus** flower. Chinnamastā originated in Hindu and Buddhist tantric traditions, and the visualization of her self-sacrifice refers to kundalini yoga, in which the body's energies are released through three channels, represented by the three flows of blood. The image therefore symbolizes spiritual enlightenment. The fact that Chinnamastā is standing on a couple in the midst of sexual intercourse implies that creation and destruction are in fact intertwined concepts.

KEY ARTWORKS

Caravaggio, *Judith Beheading Holofernes*, Galleria Nazionale d'Arte Antica, Palazzo Barberini, Rome, Italy

Master of the Death of Saint Nicholas of Münster, *Calvary*, c.1470–80, National Gallery, Washington, DC, USA

Thomas Eakins, *The Gross Clinic*, 1875, Philadelphia Museum of Art, Philadelphia, PA, USA

Ravi Varma, *Kali*, 1910–20, Metropolitan Museum of Art, New York, NY, USA

Artist unknown
Chinnamastā (India),
19th century
Coloured woodblock,
28 x 23 cm (11 x 9 in.)
British Museum, London

Chinnamastā's escorts,
as well as her own
disembodied head, drink
from the ejaculations
of sacrificial blood, in
order to share in its
regenerative powers.

EYE

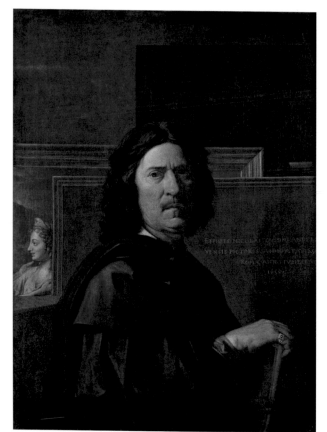

Nicolas Poussin
Self-portrait, 1650
Oil on canvas,
98 x 74 cm
(38⅝ x 29⅛ in.)
Louvre, Paris

**The woman and her
obscured partner in
the painting in the
background appear to
be an allegory of
'friendship' meeting
'painting', the latter
symbolized by an eye, the
most important sensory
organ of the artist.**

The French painter Nicolas Poussin painted his 1650 self-portrait
as a gift for his patron Paul Fréart de Chantelou. The artist had
two broad aims with this painting: the first was to summarize his
artistic philosophy, and the second was to symbolize his intellectual
relationship with Chantelou. To achieve the first objective he has
decked himself out in the black robes of a scholar, and confronts
us with a serious, foursquare gaze. His are not the only eyes present
in the image, however. One of the paintings stacked behind him
in his studio depicts a woman wearing a diadem with an eye fixed
at its centre, and a pair of arms reaching up to embrace her.
This defines the second aim of the image: to demonstrate the
cerebral connection between the patron and the painter.

This single-eye motif has a history: featured within a triangle (as it is above a pyramid on the reverse of an American one-dollar bill), it represents an omniscient 'all-seeing eye', which originated in Christian iconography. Sometimes Buddha and bodhisattvas can be represented with a third eye on their foreheads (such as *The Bodhisattva Avalokiteshvara Seated in Royal Ease* on page 118), which is capable of enhanced spiritual perception.

Before this, eye emblems were also a key part of Egyptian iconography. A pair of eyes painted on a coffin allowed the deceased sight in the afterlife, and a single eye dispelled evil. The Eye of Horus was a hybrid of a human eye and lanner **falcon** eye, incorporating the stylized dark marks on the bird's eyebrows and cheeks (for the falcon's association with Horus see page 77). According to Egyptian religion, when Horus fought his uncle Seth for the throne his eye was maimed but later healed by Thoth.

KEY ARTWORKS

Gold wedjat eye (Thonis-Heracleion), 332–330 BCE, National Museum, Alexandria, Egypt

Francesco del Cossa, *Saint Lucy*, c.1473–4, National Gallery, Washington, DC, USA

Head of the Buddha (probably Afghanistan), 300–400 CE, Victoria and Albert Museum, London, UK

René Magritte, *The False Mirror*, 1929, Museum of Modern Art (MoMA), New York, NY, USA

Artist unknown
Eye of Horus amulet,
c.664–525 BCE
Glazed composition,
5 x 6.8 x 0.7 cm
(2 x 2¾ x ⅜ in.)
British Museum, London

This amulet was small enough to be worn or held, offering portable good fortune to whoever owned it. Amulets depicting the Eye of Horus were believed to offer their owners protection and healing powers.

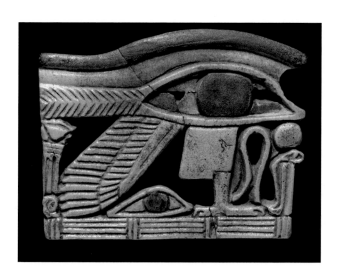

ANGEL

Angels are divine intermediaries between heaven and earth, and various types of angelic celestial beings have featured in Mesopotamian, Egyptian, Greco-Roman, Islamic, Hindu, Buddhist, Jewish and Christian religious art. In the fifth century CE the theologian Pseudo-Dionysius established the canonical subdivisions of the Christian choirs of angels in his text *The Celestial Hierarchy*. In Masolino's *Assumption of the Virgin*, painted in Florence, these ranks, and their positions relative to heaven, have been transliterated into a clangorous swarm. The hierarchy is ordered as follows:

1. Seraphim – the 'burning ones' are shown closest to the Virgin. They are red, six-winged beings whose bodies are not shown.
2. Cherubim – the 'ones who pray' are shown in the next ring outwards, in blue with four wings and here shown with no bodies.
3. Thrones – shown at the top in blue. They sometimes hold thrones, but here they bear mandorlas, which mirror the main mandorla shape containing the Virgin.
4. Dominions – who carry orbs and sceptres that were thought to emit light.
5. Principalities – holding flags of the resurrection – a red cross on a white background, also known as the flag of St George and later to be adopted as the flag of England.
6. Powers – wearing armour and bearing shields and **swords** to defeat evil.
7. Virtues – holding scrolls proclaiming their name.
8. Archangels – the order of angels that most frequently interact with humanity.
9. Angels – the lowest class of angel that are also sometimes involved with terrestrial goings-on.

Masolino
Assumption of the Virgin, central panel (reverse) from Santa Maria Maggiore triptych, Rome, 1424–8
Tempera, oil and gold on wood, 144 x 76cm (56¾ x 30 in.)
Museo di Capodimonte, Naples

Masolino's painting depicts the nine choirs of angels in their respective positions in the celestial hierarchy.

The angels present in *Shah Jahan on a Terrace, Holding a Pendant Set with His Portrait* were intended to bolster the Indian emperor's supremacy as ruler of the far-reaching and culturally enriched Mughal empire (1526–1857). His portrait is a bombastic piece of egotism: here he gazes at his own portrait miniature, his head framed by a golden **halo**, while cherub-like angels dart around the clouds, as if to honour the divine figure below.

KEY ARTWORKS

Angel seated on a carpet (Shaybanid dynasty, Bukhara), c.1555, British Museum, London, UK

Francesco Botticini, *The Assumption of the Virgin*, c.1475–6, National Gallery, London, UK

Giotto, *Lamentation of Christ*, 1305, Scrovegni Chapel, Padua, Italy

Antony Gormley, *Angel of the North*, 1998, Gateshead, Tyne and Wear, UK

Chitarman
Shah Jahan on a Terrace, Holding a Pendant Set with His Portrait, folio from the *Shah Jahan Album*, 1627–8
Ink, opaque watercolour and gold on paper, 38.9 x 25.7 cm (15⅜ x 10⅛ in.)
Metropolitan Museum of Art, New York

The presence of angels in this scene indicates that Mughal ateliers were familiar with symbols in European art, and were willing to digest, adapt and regenerate them within their own visual culture.

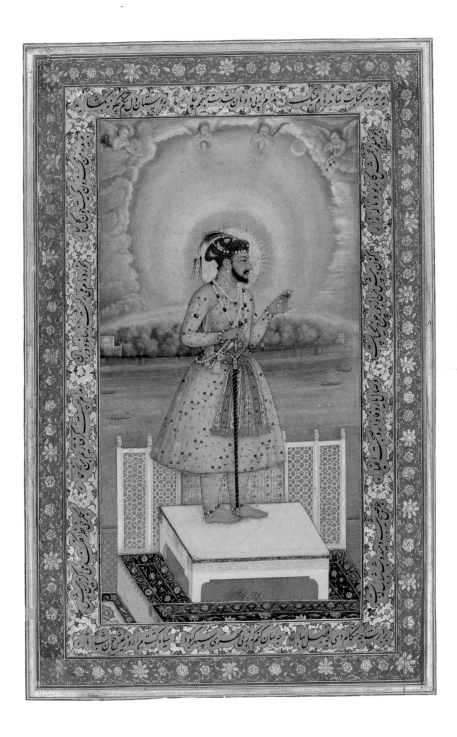

HALO

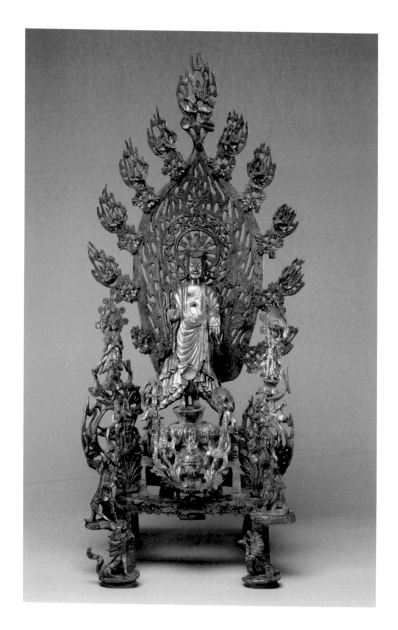

Halos – circular disks of light that symbolize holiness – appear in the imagery of countless Eurasian religions including Zoroastrianism, Mithraism, Greco-Roman mythology, Buddhism and the Vedic faiths. Christian art only began to use them in about the fifth century, where circular haloes were most common, but square haloes were deployed to show a living saint and a triangular halo was reserved for God the Father (the shape also used to house the 'all-seeing eye of God' – see page 129).

In the sixth-century sculpture (opposite) from Luoyang in China, Buddha Maitreya is both a Buddha and a bodhisattva – he is believed to be the 'future' Buddha who will appear in glory after the impending downfall of humanity. His hands are in the *varada-mudra* gesture to show protection and the granting of favour and he is accompanied by a jamboree of music-making nymphs (called *apsaras*), bodhisattvas and monks. On the base of the *Buddha Maitreya* is an inscription that explains that it was commissioned by a man whose son had died. It was his hope that he and his son would be reunited in the kingdom of purity ruled by the glorious Maitreya.

Artist unknown
Buddha Maitreya
(China), 524 CE
Gilt bronze, height
76.8 cm (30¼ in.)
Metropolitan Museum
of Art, New York

**Here the Buddha/
bodhisattva is
shown descending
to earth in majesty,
a halo immediately
behind his head and
a larger flaming halo
(mandorla) enveloping
his whole body.**

KEY ARTWORKS

Crowning Ceremony of Shapur II, 363–79 CE, Taq-e Bostan, Iran
Standing Buddha Offering Protection (India), late 5th century CE, Metropolitan Museum of Art, New York, NY, USA
Christ the Cosmocrator with Angels and San Vitale, c.546 CE, Church of San Vitale, Ravenna, Italy
Umbrian or Roman artist, *The Virgin and Child in a Mandorla with Cherubim* (Umbria, Italy), c.1480–1500, National Gallery, London, UK

POSSESSIONS

-

It is through symbols that man consciously or unconsciously lives, works and has his being

-

Thomas Carlyle
1836

SHELL

A passive, limply gesturing Venus, naked save for her gold jewellery, is shown skating gently across the waves on a cockle shell, haloed by the shell-shaped canopy of her billowing veil. *Venus on a Seashell* was an image designed to seduce the gaze of its Pompeiian audience, who worshipped Venus not just as the goddess of love and beauty, but also as the tutelary deity of the city itself. It is an image that unites two common associations of shells in art history: femininity and procreation. Venus's birth is said to have occurred after the Titan Cronos castrated his father Uranus and threw the severed genitalia into the sea. The goddess was conceived by the intercourse of semen and seawater, born out of a shell and washed to the shore by the waves.

Shells' association with fecundity derives from their links to **water**. One of the Hindu deity Vishnu's four attributes is a shell, and in *Vishnu in His Cosmic Sleep* from Uttar Pradesh, India, the god is depicted holding a conch in his foremost left hand. Vishnu is sleeping in the primordial **waters**, creating the world as he does so. The mighty, multi-headed **snake** Anata (which can be seen encircling Vishnu on the left of the sculpture) is his bed, and a lotus plant emerges from his navel, on which sits Brahma. The conch shell refers to his embryonic watery environment and is therefore a symbol of birth, just as it was for the Aphrodite/Venus myth.

Artist unknown
Venus on a Seashell, in room 8 of Casa della Venere in Conchiglia, before 79 CE
Fresco
Pompeii, Italy

This fresco anticipates – in its flattened form and centralized composition – the later and more famous Renaissance *Birth of Venus* by Botticelli, as well as any number of supine female nudes from the western tradition.

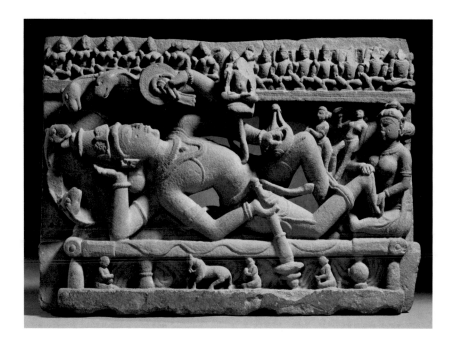

Artist unknown
Vishnu in His Cosmic Sleep, 11th century
Sandstone,
36.8 x 55.9 x 11.4 cm
(14½ x 22 x 4½ in.)
Los Angeles County
Museum of Art,
Los Angeles

The conch shell is Vishnu's most frequent attribute, and in this representation he holds it against his left thigh.

Alongside femininity and propagation, shells have other diverse meanings in different contexts. In Benin cowrie shells were a recognized currency and sculptures from this and other African regions often incorporated these shells to signify wealth and power. In Hinduism generally the conch shell is an important symbol and is used as a **trumpet** in ritual. In Europe a scallop shell was the symbol of St James the Great, one of Jesus' Twelve Apostles. Many Christians believe his remains were interred at Santiago de Compostela, which has become a major pilgrimage destination, and so the shell has also become an emblem for pilgrims.

KEY ARTWORKS

Sandro Botticelli, *The Birth of Venus*, c.1485, Uffizi Gallery, Florence, Italy

Caravaggio, *The Supper at Emmaus*, 1601, National Gallery, London, UK

Helmet Mask, before 1880 (Bamum Kingdom, Cameroon), Metropolitan Museum of Art, New York, NY, USA

Eileen Agar, *The Autobiography of an Embryo*, 1933–4, Tate, London, UK

BOW AND ARROW

Arrows are frequently a symbol of military authority and hunters. The Egyptian pharaohs, for example, would symbolize their sovereignty over the world by ceremoniously shooting four arrows towards the four points of the compass. In the seventh century BCE, the Assyrian King Assurbanipal saw the arrow as an emblem of decisive authority, capable of inflicting a long-range strike on his foes. The **lion**, represented in the relief above with maximum sinew-straining aggression, counterpoints Assurbanipal's cool efficiency as a subjugator of dissent.

In other contexts arrows are the tool of love rather than war. The child god Eros/Cupid from Greco-Roman mythology, who appears in Agnolo Bronzino's *Venus and Cupid*, possessed a gold-tipped arrow that had the power to incite passionate love in whoever it struck. Yet the exact role of the arrow and the other figures and objects in Bronzino's painting are contested by art historians. It was a gift for Francis I, king of France, from Cosimo I de' Medici, the grand duke of Tuscany. This may explain the image's complexity: Cosimo knew that Francis I would relish the task of unriddling its abstruse symbols – just as much as he would enjoy scrutinizing its sumptuous expanses of nude flesh and fabrics. Bronzino was the perfect artist for such a challenge because he was a poet as well as a painter. His verse was erotic, euphemistic and allusive, and almost every word contained a double, darker meaning.

Artist unknown
Hunting Lions, hall relief from the North Palace, Ninevah (now North Iraq), c.645–635 BCE
Gypsum,
63.5 x 71.1 cm
(25 x 28 in.)
British Museum, London

This scene from the North Palace at Ninevah is an allegory of Assyrian King Assurbanipal's wars against his enemies the Egyptians, Elamites and Babylonians, with the arrow connoting his armies' powers over them.

Venus and Cupid adopts those poetic skills into an image, relying on the viewer's understanding of the various symbols' associations and subverting our expectation of a scene that contains the goddess of love and her son. Cupid's golden arrows are the darts of love, and yet the figures surrounding the pair – anguished Jealousy (which might be an allegory of syphilis), childish Pleasure (too stupefied to feel the thorns piercing his feet), Deceit with her honeycomb and venomous tail, moralizing Father Time and the **masks** of Deception – all seem to indicate the sinister repercussions of passion.

KEY ARTWORKS

Mounted Warrior, 14th century, Kyoto National Museum, Kyoto, Japan

Paolo Veronese, *Allegory of Love II (Scorn)*, mid-1540s, National Gallery, London, UK

The Emperor Jahangir with Bow and Arrow, c.1603, Arthur M. Sackler Gallery, Washington, DC, USA

Sir Joshua Reynolds, *Colonel Acland and Lord Sydney: The Archers*, 1769, Tate, London, UK

Agnolo Bronzino
Venus and Cupid, c.1545
Oil on panel,
146.1 x 116.2 cm
(57½ x 45¾ in.)
National Gallery, London

There appears to be a mutual act of deception at the centre of the painting: Venus is stealing an arrow from Cupid's quiver while he teasingly burgles the crown from her head.

CROWN

A crown is one of the clearest symbols of dominion and glory, and in art they can be the attributes of triumphant deities, earthly rulers or the champions of culture and sport.

The king represented on the terracotta bust (opposite) from Ife, a city in what is now Nigeria, is wearing a beaded crown known as an *adenla*. In Ife culture the king was regarded as a divine figure, whose crown was not simply a symbol of status; the act of wearing it was believed to connect him with the spirits of every previous sovereign. Sculptures such as this were buried beneath sacred trees; it is thought that they would later be dug up for use in future ceremonies. The bust visualized two aspects of the king's role. On one hand, the crown conveyed his superhuman divinity and role in the lineage of Yoruba royalty; on the other hand, his mortality and individuality were communicated through the breathtakingly delicate rendition of his bone structure and soft flesh.

Crowns come in many forms in art history. In Ancient Egypt a white crown symbolized the rule of Upper Egypt while a red one was for dominion of Lower Egypt – and a double crown signified rule over the whole territory. Shiva, Buddhist deities and other mythological ruler-gods can be found wearing crown-like headgear. In Christian art a crown can be glorious, as in the scenes of the Virgin's coronation in heaven, or tragic, as in the crown of thorns, which is a symbol of Jesus's crucifixion. In European allegory a **laurel** wreath is a crown of victory, but in a *vanitas* painting it can symbolize the futility of worldly power.

Artist unknown
Head, possibly a king (Ife), 12th–14th century
Terracotta with residue of red pigment and traces of mica,
26.7 x 14.5 x 18.7 cm (10½ x 5⅝ x 7⅜ in.)
Kimbell Art Museum, Fort Worth

The grace and truthfulness of the facial features in this portrait might steal attention from the crown, yet the headgear held symbolic significance to the Yoruba people.

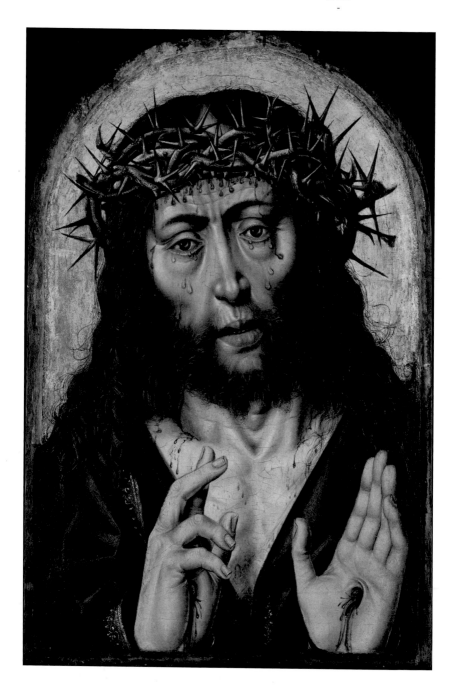

**Workshop of
Aelbert Bouts**
*The Man of
Sorrows*, c.1525
Oil on oak,
44.5 x 28.6 cm
(17½ x 11¼ in.)
Metropolitan Museum
of Art, New York

**Bouts has made the
suffering of Jesus more
vivid by depicting the
thorns as unnaturally
long and emphasizing
the reddened eyes and
the tears on His cheeks.**

Bouts's painting is one such representation of the crown of
thorns, which is among the most profound symbols of humility in
Christian iconography. It shows the results of the Passion – the
series of events that started with Jesus' arrest and ended with His
execution. It has been painted with a dedication to realism: each
strand of hair on Jesus' head has been individually represented and,
gruesomely, bluish vertical lines have been depicted on His forehead
to show where the thorns have embedded themselves beneath the
skin. Within this simple scene the crown, **halo, blood** and the **hand
gesture** of blessing are all that are needed to communicate meaning.

This non-narrative type of image where the focus is placed on
Jesus' physical and mental suffering is known as a 'Man of Sorrows'.
According to scripture, the crown of thorns itself was put on
Jesus' head by His Roman executioners to taunt Him – they also
dressed Him in mock-imperial robes and subjected Him to an ironic
coronation, using the refrain: 'Hail, King of the Jews.' The motif of
the crown of thorns in art became increasingly popular from the
late medieval period onwards, when European religious writers and
artists became fixated on episodes of Jesus' suffering.

KEY ARTWORKS
Statuette of the Crocodile-headed God Sobek (Egypt),
 c.664–332 BCE, Louvre, Paris, France
Benin Plaque, 16th century, British Museum, London, UK
Sir Anthony van Dyck, *The Crowning with Thorns*, 1618–20,
 Museo del Prado, Madrid, Spain
Jacques-Louis David, *Napoleon Crowning Himself Emperor before
 the Pope*, 1805, Louvre, Paris, France

MASK

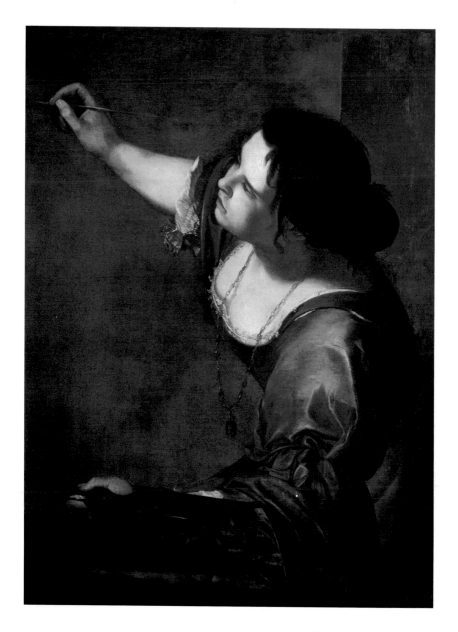

Artemisia Gentileschi
Self-portrait as an Allegory of Painting, c.1638–9
Oil on canvas,
96.5 x 73.7 cm
(38 x 29 in.)
Royal Collection,
Hampton Court Palace

Masks can symbolize the imitation of life. In Artemisia Gentileschi's painting the mask pendant has been turned to face the artist's palette and brushes – the tools of her creativity.

Masks are linked to creativity, rituals and performance across world cultures. Artemisia Gentileschi is wearing one in her *Self-portrait as an Allegory of Painting* (painted in London): however, it is not one that covers her face. Her mask is in fact a piece of jewellery – a necklace pendant that dangles free as she leans forward to paint. Gentileschi included this tiny emblem because this was one of the accoutrements of the conventional, art-historical personification of the art of 'Painting'.

Other paraphernalia of the figure traditionally included a mouth gag to show that painting is a mute art form, a shot-silk dress to indicate the use of colour, a paintbrush and palette, and a sweaty brow to express creative agitation (a feature shared by Sir Anthony van Dyck in his self-portrait on page 59). These attributes of Painting – or Pittura – were defined in a dictionary of allegorical figures called the *Iconologia* by Cesare Ripa, first published in 1593. Ripa constructed the look of his allegories from various historical sources including classical Greece, where masks were used in theatrical performances to amplify the actor's voice and allow them to successfully inhabit a diversity of roles, which would have included different genders, classes and ages. Ripa's suggestion is therefore that painters, like actors, should perfect the skill of imitating life.

Self-portraits usually show painters face-on. This is down to both tradition and common sense: it's a lot easier to paint your own features accurately by looking directly into a mirror. Gentileschi has selected a much more problematic pose, leaning inwards towards the viewer, with her face at an angle. She can only have managed

to depict herself this way by using an ingenious system of angled mirrors. The hard toil of artists is a theme underscored throughout the painting. Her palette is thrust out towards us in a gripped fist resting on a polished stone – the type of surface on which artists used to grind their pigments. She wears a brown apron, and her right arm and wrist are shown as muscular, suggesting a lifetime of manual work. Tellingly, Gentileschi has not included the gag stipulated by Cesare Ripa. To have done so would have suggested submissiveness – not the message that this female painter in an overwhelmingly male-dominated artistic pool wanted to project.

Gentileschi's brush hovers above the canvas: she has shown herself in a liminal moment between observing and recording. It is the most exciting, tentative and frustrating part of being a painter – how to make a mark with a brush that accurately and meaningfully transcribes an aspect of the ever-changing real world: how to use false imitation to engage with true ideas. The mask on *Pittura* reminds us of this struggle. As Cesare Ripa put it: 'Imitation is a discourse that, even if false, was done with the guide of some truth that had happened.'

Masks are also a feature of Japanese drama, and the Metropolitan Museum's *Hannya Mask Netsuke* shows the theatrical mask of a demonic female character that appears in *Noh* and *Kyōgen* dramas. Japanese *netsuke* are ornamental sculptures that are attached to the traditional robes of Japanese men.

KEY ARTWORKS

Gold Mask of Agamemnon (Greek), c.1550–1500 BCE, National
 Archaeological Museum, Athens, Greece
Terracotta Tragic Theatre Male Mask (Roman),
 3rd–2nd century BCE, British Museum, London, UK
Queen Mother Pendant Mask (Iyoba), 16th century, Metropolitan
 Museum of Art, New York, NY, USA
Nicolas Poussin, *The Triumph of Pan*, 1636, National Gallery,
 London, UK

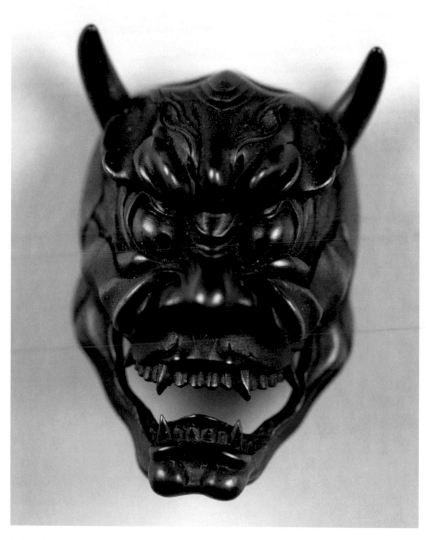

Artist unknown
Hannya Mask Netsuke,
19th century
Wood, height 3.2 cm
(1¼ in.)
Metropolitan Museum
of Art, New York

This *netsuke* depicts a
mask that would have
been worn by Hannya, a
demonic manifestation
of a woman's jealousy
in Japanese drama.
Despite its miniature
scale, the facial muscular
contortions have been
represented with great
attention to detail.

SCALES

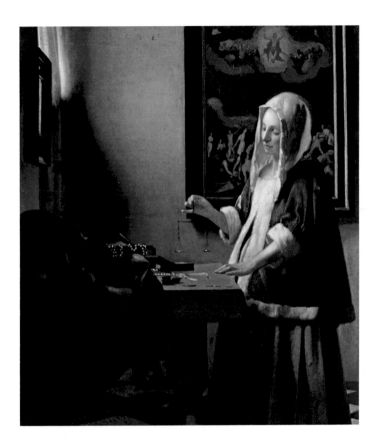

Weighing scales are almost always depicted in art with someone
holding them – they are a symbol of judgement, and by extension
the equanimity, balance and fairmindedness of the judge. Osiris
weighing souls in the Hall of Judgement was a common motif
in Egyptian imagery: a human heart (representing the soul) was
balanced against a feather – if it was heavier you were condemned,
if it was lighter you would proceed to the afterlife. In Christian
iconography St Michael is often shown with a set of scales in
Last Judgement scenes, weighing the souls of the deceased and
dispatching them either to heaven or hell – a role also sometimes

given to Hermes/Mercury in Greco-Roman art. Weighing scales can be seen held by allegories of justice, as well as one of the four horsemen of the apocalypse.

The pans of a set of weighing scales teeter towards neutral in Vermeer's *Woman Holding a Balance*, silently watched by the woman at the heart of this immaculate Dutch interior. The painting exemplifies the artist's remarkable abilities with oil paint, particularly his method of representing the effects of light through licks, dabs and flecks of pigment that skilfully suggest rays glinting off the surfaces of various materials. To what end? *Woman Holding a Balance* does not show a momentous moment in history or religion but an everyday moment: a door opened onto an uneventful seventeenth-century Dutch living room. But the presence of the symbolic weighing scales, in conjunction with the Last Judgement scene on the wall behind her, suggests that an encrypted message lies beneath the surface.

Vermeer was a Catholic painter in the Protestant Dutch Republic. He did not have the opportunity to paint prestigious, church-commissioned religious scenes since Protestantism had deemed that art was in contravention to doctrines laid down in the Bible about idolatry. As a result Vermeer's religious thoughts disguised themselves among the humdrum of everyday life scenes, which was the most popular genre of art for the wealthy and art-hungry Dutch professional and merchant classes. *Woman Holding a Balance* could be passed over as a portrayal of a commonplace activity, but it could also be understood as an allegory of the vanities of life. As a respectably dressed woman, who lowers her eyes from the **mirror** opposite, she can be considered to represent virtue. The scales are placed in the dead centre of the composition, dividing the materialistic from the spiritual half of the scene. Meanwhile the pans gently oscillate between the two while we, the spectator, are invited to mull over which side our souls might belong to.

Johannes Vermeer
*Woman Holding
a Balance*, c.1664
Oil on canvas,
39.7 x 35.5 cm
(15⅝ x 14 in.)
National Gallery,
Washington, DC

Vermeer subtly draws our attention to the weighing scales in this painting by placing them at the composition's vanishing point and aligning them with the central verticals of the picture frame and table leg.

KEY ARTWORKS

Page from the Book of the Dead of Ani (Egypt), c.1275 BCE,
British Museum, London, UK
Attributed to the Syracuse painter, *Hermes Psychostasia* (*Weigher of Souls*; Greece), c.490–480 BCE, ceramic vase, Museum of Fine Arts, Boston, CT, USA
Hans Memling, *The Last Judgement*, c.1471, National Museum, Gdańsk, Poland
Albrecht Dürer, *Apocalypse*, 1497–8, British Museum, London, UK

SWORD

In western art history, a **sword** stands as a symbol of masculine courage, authority and justice, and in Buddhism and Daoism it represents the cutting away of ignorance and evil, thus symbolizing spiritual intelligence. As the weapon of royalty and the aristocracy, it signifies their right to rule and to defend and dispense honour – something that is preserved today in formal swords of state and in knighting ceremonies.

In *Saint Michael Triumphs over the Devil* (opposite), probably from the central panel of an altarpiece, Bartolomé Bermejo uses conventional artistic iconography. It was painted in Spain a short time before the culmination of a civil war known as the '*reconquista*', in which the Muslim population (which had been present in Spain since the eighth century) was defeated by the Christians. There is an obvious analogy between this and the subject matter of the painting: Saint Michael, the archangel, fighting for God against the rebel **angels** led by Satan – in this case represented by an unearthly demon. The sword that Michael holds as he prepares to smite Satan is a symbol of divine justice.

There is a sword in the right-hand panel of Kara Walker's *40 Acres of Mules* (overleaf), dangling, sheathed, on the belt of a confederate army officer. But as much else in the painting, and in Kara Walker's oeuvre in general, the iconography has been subverted for satirical effect.

Walker took her inspiration from an enormous stone relief in the side of Stone Mountain in the state of Georgia that shows three confederate leaders from the civil war: Jefferson Davis, Robert E. Lee and 'Stonewall' Jackson. Stone Mountain Park became a regular meeting place for the Ku Klux Klan and a site for cross burning. The title of Walker's drawing is a reference to the phrase 'forty acres and a mule' – a promise to freed slaves in the 1860s that they would be granted land and animals, a pledge that was ultimately broken.

Walker draws upon conventional representations of the crucifixion in her drawing. Its triptych format is synonymous with European altarpieces, and in the central section a lynched figure

Bartolomé Bermejo
*Saint Michael Triumphs
over the Devil*, 1468
Oil and gold on wood,
179.7 x 81.9cm
(70¾ x 32¼ in.)
National Gallery, London

**The kneeling figure is the
patron of this painting
Antoni Joan, lord of
the town of Tous, near
Valencia. He is focused
on St Michael's sword
poised to strike the
dragon, while holding
a smaller sword in the
crook of his arm – a
symbol of his nobility.**

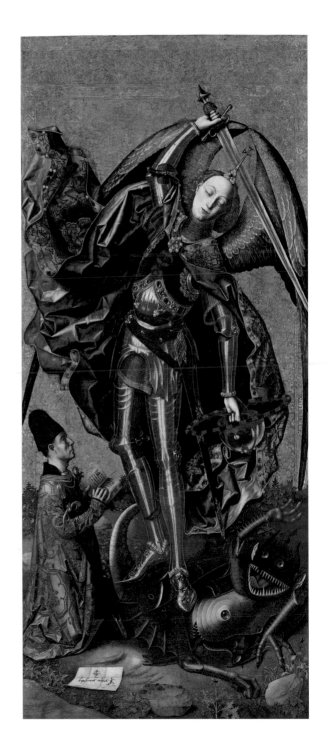

beneath the cross of a confederate flag is being pierced in his side, a similarity to what happened to Christ. Ku Klux Klansmen, white soldiers, women, donkeys and rearing horses stand in for the saints and Roman executioners. But any reverence we might associate with the crucifixion has here degenerated into an unrestrained orgy of emasculation, sexual violence and racist sadism.

According to Kara Walker the afflicted black body in the centre of the composition represented:

a substantial threat socially, psychologically, sexually, and had to be, or was, in fact, destroyed. The black body itself could never satisfactorily die enough for the white ruling class to breathe

Kara Walker
40 Acres of Mules, 2015
Charcoal on paper,
triptych, each panel
differs, from left to right:
264.2 x 182.9 cm
(104 x 72 in.);
261.6 x 182.9 cm
(103 x 72 in.);
266.7 x 182.9 cm
(105 x 72 in.)
Museum of Modern Art
(MoMA), New York

easy. That body is representative of all bodies that are oppressed or subjected to this kind of psychosexual torture.

KEY ARTWORKS

Donatello, *Equestrian Statue of Gattamelata*, 1453, Piazza del Santo, Padua, Italy

The Battle of Badr, from Mustafa Darir, *Siyar-I Nabi* (*Life of the Prophet*; Ottoman Turkey), c.1594, manuscript, British Museum, London, UK

Artemisia Gentileschi, *Judith Slaying Holofernes*, c.1611–12, National Museum of Capodimonte, Naples, Italy

Jean-Michel Basquiat, *Warrior*, 1982, private collection

TRUMPET

Early one of these mornings,
God's a-going to call for Gabriel,
That tall, bright angel, Gabriel;
And God's a-going to say to him: Gabriel,
Blow your silver trumpet,
And wake the living nations.
And Gabriel's going to ask him: Lord,
How loud must I blow it?
And God's a-going to tell him: Gabriel,
Blow it calm and easy.
Then putting one foot on the mountain top,
And the other in the middle of the sea,
Gabriel's going to stand and blow his horn,
To wake the living nations.

This is a fragment of James Weldon Johnson's 1927 poem
'The Judgment Day', which was inspired by the rhetorical skills
of black evangelists in Kansas City. Aaron Douglas was a friend
and fellow member of the Harlem Renaissance, and was asked by
Johnson to complement his verse with images. Douglas's painting
depicts the **angel** Gabriel bounding forth amid **lightning** strikes and
sea storms and blowing his trumpet to call the souls of the world
out of their earthly hiding places and towards divine judgement.
Douglas's style was influenced by Cubism and Futurism, as well
as African sculpture and Egyptian imagery, and it is easy to catch
Douglas emulating the lusty cadence of Johnson's verse in his
kinetic bands of colour and the assertive, bestriding protagonist.

As well as in images of angels proclaiming the Day of Judgement,
trumpets are also generally a symbol of broadcasted messages. In
European art a trumpet is the attribute of the allegory of Fame, the
muses such as Clio (see Vermeer's *Art of Painting* on page 42) and
of heralds in Roman triumphal processions. Triton, the sea-bound
follower of Poseidon/Neptune, is often shown trumpeting his
master's fame with a conch **shell**.

Aaron Douglas
The Judgement Day, 1939
Oil on tempered
hardboard,
121.9 x 91.4 cm
(48 x 36 in.)
National Gallery,
Washington, DC

**The giant angel in
Douglas's painting blows
a trumpet, corresponding
to the description of the
apocalypse in the biblical
Book of Revelation.
This describes how on
the Judgement Day
seven trumpet blasts
will announce the end
of the world, with each
one causing a different
cataclysmic event.**

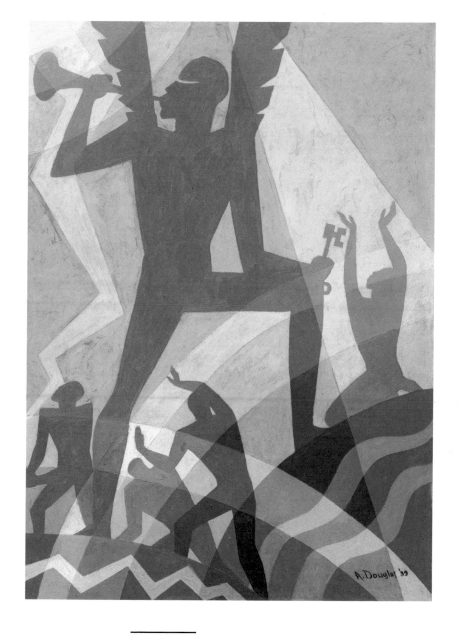

KEY ARTWORKS

Dervish with Horn and Begging Bowl (Iran), early 17th century, British Museum, London, UK

Sir Edward Coley Burne-Jones, Bt, *The Golden Stairs*, 1880, Tate, London, UK

Wassily Kandinsky, *All Saints I*, 1911, Munich, The Städtische Galerie im Lenbachhaus, Munich, Germany

Max Beckmann, *Carnival*, 1920, Tate, London, UK

TIMEPIECE

The first time an hourglass appeared in European art was during the Middle Ages. Its symbolic meaning is straightforward: it represents the passage of time, the transience of life or the inevitability of death. Chronometers, sundials, clocks and other kinds of timepiece generally have the same significance. Such items feature frequently in *vanitas* paintings and in the hands of the personifications of Temperance, Death or Time.

An hourglass appears in the upper right-hand corner of *Melencolia I*, created in Nuremburg in 1517. It is one of the few symbols that Dürer used in his *Meisterstiche* (master engravings) that comprised of *Melencolia I* and two other contemporaneous prints, *The Knight* (1513) and *St Jerome* (1514). It clearly had a special significance.

Melencolia I has inspired endless debate and remains something of a mystery. It is a teasing image, rewarding the viewer on the one hand with its finessed skill in the art of engraving, and frustrating her on the other with its complex and enigmatic symbols, including the hourglass. Even the most fundamental questions are unresolved, such as the identity of the central figure, who could be an angel or an allegory. If the latter is true then yet more unknowns present themselves: scholars disagreed as to what she represents: Melancholy or Geometry, or another as-yet-unidentified concept.

The cause of her misery is still ultimately unknown, as are the events in the sky that might either represent a comet or a light-emitting moon. Writers have gone on to speculate on Dürer's sources of inspiration which include the ideas of Copernicus, alchemy, Platonic philosophy, medical writing and astrology. It all comes down to a lack of certainty about the significance of the image's symbols, of which the hourglass shares in the overall mystery. Is it a tool of measurement, analysis and creation, just like the many other instruments scattered around the scene? Is it the cause of grief, or a consolation to us that frustrations are merely temporary?

Albrecht Dürer
Melencolia I, 1514
Engraving,
24.2 x 18.8 cm
(9½ x 7⅜ in.)
National Gallery,
Washington, DC

This engraving is full of ambiguity that has led some scholars to suggest that *Melencolia I* is purposefully unsolvable – a sophisticated joke about the limits of symbolism and allegory. Is the hourglass an emblem of the limited time available to solve and create?

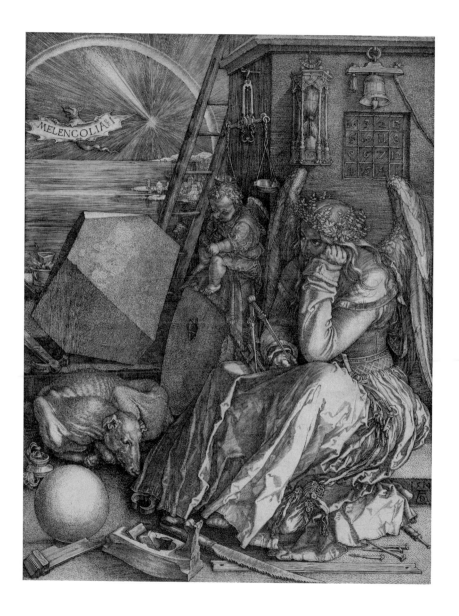

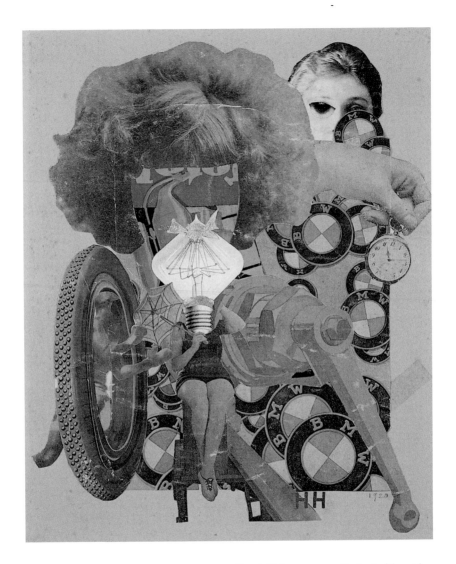

Hannah Höch
Das schöne Mädchen
(*The Beautiful Girl*), 1920
Photomontage,
35 x 29 cm
(13¾ x 11½ in.)
Private collection

The hands of the watch
are a *memento mori*,
reminding us of the
lifeless routines of
industry: the regularity of
the working day and the
pressures of productivity.

Hannah Höch's *Das schöne Mädchen* (*The Beautiful Girl*) presents us with a modernized iconography, fresh for the industrialized twentieth century, comprising of corporate logos, a crank shaft, rubber tyre, light bulb, modish female fashions and a pocket watch. It captures for us something of the changing role of women within the mechanized and rapidly changing environment of Weimar Germany. Women were increasingly employed as members of the national workforce, yet still expected to fulfil expectations about traditional feminine roles and deportment.

The clash of the stereotyped image of a swimsuit-wearing young woman and her industrial surroundings articulates this fluctuation in societal roles. Revolution is further visualized in the images with every wheel and cog being in motion: even the BMW logos, which were originally designed to represent a white propeller rotating before a blue sky. The pocket watch is shown with an unobstructed face, unlike the human characters, and may fulfil the same function as the hourglass in Dürer's *Melencolia I* – symbolizing an oppressive tool of measurement and expectation.

KEY ARTWORKS

Nicolas Poussin, *A Dance to the Music of Time*, c.1634–6, Wallace Collection, London, UK

Harmen Steenwyck, *An Allegory of the Vanities of Human Life*, c.1640, National Gallery, London, UK

Dante Gabriel Rossetti, *La Pia de' Tolomei*, 1868–80, Spencer Museum of Art, Lawrence, KS, USA

Salvador Dalí, *The Persistence of Memory*, 1931, Museum of Modern Art, New York, NY, USA

MIRROR

Mirrors have had a particular resonance with artists from a wide variety of different regions through history, not simply because they are a tool to aid their work, but because they both have essentially the same duty: to echo the visual environment. The earliest known mirrors date from the sixth millennium BCE in the form of plates of polished obsidian, a stone that is mined from revered volcanic **mountains** and recovered from the Neolithic settlement of Çatalhöyük in Turkey. The first paintings that feature people holding mirrors come from Ancient Egypt, around the second millennium BCE. In later Greco-Roman sculpture Aphrodite/ Venus, the goddess of love, was shown holding a mirror and admiring her own superlative beauty.

Over time mirrors were associated with certain vices and virtues in European art including the qualities of truth and purity (because the mirror reflects dispassionately) but conversely also vanity (because it encourages self-obsession). Mirrors have also been used for occult purposes in Europe, with diviners searching the hazy reflections for signs of prophecy. In Asia mirrors were once believed to be magical instruments that could perceive the soul of the viewer and were decorated with auspicious motifs. In Japan a mirror is one of the three sacred relics of the emperor.

When Diego Velázquez painted the goddess Aphrodite/Venus, he broke certain conventions of the genre. Depicting the female from behind was one such innovation (it was conventional to depict a frontal Venus in the manner of the *Venus on a Seashell* on page 138), but Velázquez also distorted her reflection in the mirror held by her son Cupid/Eros. She is looking at us rather than at herself, in a provocative reciprocation of our own act of looking.

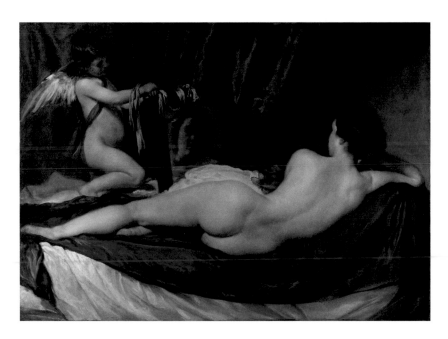

Diego Velázquez
Rokeby Venus, c.1647–51
Oil on canvas,
122 x 177 cm
(48 x 69¾ in.)
National Gallery, London

Rather than delineate Venus's fabled beauty, Velázquez has shown her out of focus, either to underscore her mystic unavailability to mortals or for some other private reason, perhaps to conceal the identity of the woman who posed for him.

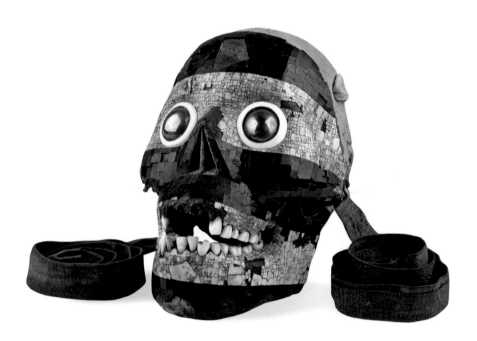

Artist unknown
*Mosaic skull of
Tezcatlipoca* (Aztec),
c.15th–16th century
Turquoise, pyrite,
pine, lignite, human
bone, deer skin,
conch shell and agave,
19 x 13.9 x 12.2 cm
(7½ x 5½ x 4⅞ in.)
British Museum, London

**Obsidian mirrors are
usually shown on the
faces of Tezcatlipoca,
but here the black
lignite mosaic and his
highly polished pyrite
eyes suffice to convey
the deity's oracular and
purgatorial authority.**

The magical aspect of mirrors is evident in the British Museum's *Mosaic skull of Tezcatlipoca*. This Aztec god – the lord of the Smoking Mirror – was one of their most important deities and the enemy of Quetzalcoatl (see the *Double-headed Serpent* on page 100). He was the all-powerful god of black obsidian. Sacrificial knives were made from obsidian, but it was also used in the production of 'black mirrors' of divination, which would later become objects of fascination for European seers. As a result of these various associations, Tezcatlipoca was considered to be the originator of the rite of human sacrifice, the master of fate and possessor of supernatural powers of insight.

KEY ARTWORKS

Jan van Eyck, *The Arnolfini Portrait*, 1434, National Gallery, London, UK

Titian, *Venus with a Mirror*, 1555, National Gallery, Washington, DC, USA

Caravaggio, *Martha and Mary Magdalene*, 1598, Detroit Institute of Arts, MI, USA

Joan Jonas, *Mirror Piece I*, 1969, Guggenheim Museum, New York, NY, USA

-

**Man walks through woods
of symbols, dark and dense,
Which gaze at him with fond
familiar eyes**

-

Charles Baudelaire
1857

GLOSSARY

Agni: in Sanskrit the word means 'fire', but it also refers to the Hindu god of fire who resides within ritual flame.

Alchemy: a precursor to modern chemistry that was concerned with the metamorphosis of materials and how to transform everyday matter into gold. Alchemists used a system of symbols that were sometimes applied in the visual arts.

Allegory: in art, the representation of concepts (such as emotions, nations or skills) through another form such as a human figure or associated objects.

Apsara: a dancing girl represented in Indian art – originally a water sprite in the Vedic religions and later also musicians.

Assyrian: relating to the city-state of Ashur (which was located in what is now northern Iraq) and its empires, the most powerful of which was known as the Neo-Assyrian empire and lasted from the ninth to seventh centuries BCE.

Attribute: the objects held by allegories, deities and other religious figures in order for spectators to identify them.

Aureole: a halo of light around a head or whole figure.

Aztec: a name given to the peoples who controlled an empire in central Mexico between the fouteenth and sixteenth centuries CE.

Babylonian: relating to the ancient city of Babylon and its empire. The city was located in what is now Iraq, and its most powerful period was between the seventh and sixth centuries BCE.

Baroque: a seventeenth-century style in Europe that started in Rome. It was remarkable for its dramatic use of space, psychological impact and sense of movement and grandeur.

Bodhisattva: in Buddhism, a person who has attained enlightenment but chooses to remain among mortals to help them on their path to salvation.

Book of Revelation: the final book of the Christian New Testament. It foretells the end of the world, and details the disastrous events that surround it.

Canon, canonical: in art historical usage, a collective of artworks, artists or art practises that have been given formal acceptance and deemed significant or definitive.

Cornucopia: a horn of plenty that overflows with flowers, vegetables and fruit to symbolize abundance.

Cubism: an early twentieth-century style initiated by Pablo Picasso and Georges Braque that aimed to show life from different perspectives simultaneously by breaking up natural form into geometrical structures and pioneering the use of collage.

Dharmachakra: a wheel-shaped motif used in India, and visible in both Hindu and Buddhist religious symbolism, to signify change, wisdom and the cyclical nature of time.

Emblemata: textbooks defining emblems in the visual arts, the first of which was written by the Italian Andrea Alciato in 1531. They acted as dictionaries of symbols for artists.

Futurism: an Italian art movement of the early twentieth century that took as its subject the speed and power of modern technology.

Greco-Roman: relating to the cultures of Ancient Greece and Rome.

Hieroglyphs: a written language composed of signs and pictures to represent words or syllables, notably in Ancient Egypt.

Ichthys: the fish-shaped symbol of Christianity.

Iconography: the art historical study of subjects in art and their interpretations, including the study of symbols.

Land Art: a movement from the later twentieth century in which practitioners made art about nature by using its materials directly, and working within it rather than depicting it.

LGBTQ movement: a movement promoting the rights of lesbian, gay, bisexual and transgender people and people with other gender and sexual identities.

Mandala: a schematic representation of universe, used for meditation in Hinduism and Buddhism.

Mandorla: an almond-shaped halo around the body of a deity.

Memento mori: a reminder of death, such as a skull, that suggests the transience of life and the inevitability of death.

Mesopotamia: area of southwestern Asia (modern-day Iraq, and parts of Turkey and Syria) considered to be a highly significant region for the development of urbanized civilization in Eurasia.

Mithraism: a religion based around the worship of the Persian deity Mithra, popular among the peoples of the Roman empire between the first and third centuries BCE.

Mughal empire: a Muslim dynasty that ruled northern India between 1526 and 1857.

Personification: representing a concept in the form of a human.

Pictogram: a symbol used in signage that denotes something by representing it in a recognizable form, such as a crossroads sign that uses a cross shape.

Pilgrimage: a journey to a place of religious significance.

Pre-Columbian: the period and cultures of the Americas that existed before the arrival of Christopher Columbus and further European explorers.

Pre-Raphaelite: a British art movement that flourished in the second half of the nineteenth century. It emulated medieval and early Renaissance art and prioritized the language of symbols.

Putto (pl. *putti*): a type of figure usually found in European art, who represents lustfulness or playfulness, represented as a plump young boy.

Quattrocento: the period of the early Renaissance, from 1400 to 1500 in Italy.

Rebus: a type of picture-puzzle in which a word or sentence is represented by an image or sequence of images. The puzzle is solved by speaking the images aloud.

Renaissance: the period of intellectual and artistic development, inspired by the classical world, that occurred in Europe between approximately 1400 and 1580. Its most famous artists include Michelangelo, Leonardo da Vinci, Raphael and Dürer.

Royal Academy: an academy is a school of art, the first of which were established during the Renaissance. The classical style was seen as the ideal model for emulation within these institutions. In some countries, the monarchy gave official backing to such institutions.

Shen ring: an Ancient Egyptian symbol of a circle with a line beneath or beside it to represent 'encircle' or 'protection'.

Shinto: an indigenous Japanese religion based around devotion to invisible spirits called *kami*.

Sumerian: relating to the peoples of Sumer, in modern-day southern Iraq, whose cities and cultures flourished between c.3500 and 1900 BCE.

Surrealism: a twentieth-century art movement inspired by psychology and a fascination with dreams and the irrationality of the human mind.

Ukiyo-e: 'pictures of the floating world' – images from Japan made between the seventeenth and nineteenth centuries. This was a popular art focused on everyday life, landscapes and subjects from folklore and legend.

Vajra: a symbolic weapon in Buddhism and Hinduism that synthesizes the appearance of a thunderbolt and a diamond.

Vanishing point: in images that depict spatial depth using one-point perspective, parallel lines extending away from the viewer appear to converge at their furthest point from the viewer. The point at which they meet is called the vanishing point.

Vanitas: a type of art or a symbol within a work of art that serves as a reminder of the futility of earthly possessions, wealth and worldly success.

Video Art: art that uses the recorded moving image (in the form of video and television).

Wedjat eye: a stylized motif from Ancient Egypt depicting the Eye of Horus, which was believed to carry healing properties.

Yin and yang: dualism of forces in Ancient Chinese philosophy manifested in such binaries as light and dark, negative and positive, and male and female. The unity of these forces was believed to bring harmony.

Zoroastrianism: an ancient (but still practised) Persian religion, based on the teachings of the prophet Zoroaster (also known as Zarathustra and Zardusht). Dating the beginnings of Zoroastrianism is problematic – it may have begun around 1000 BCE or earlier, although some scholars suggest a later date of the seventh or sixth century BCE.

FURTHER READING

Battistini, Matilde, *Symbols and Allegories in Art* (Getty Publishing, Los Angeles, LA, 2005)

Cooper, J. C., *An Illustrated Encyclopaedia of Traditional Symbols* (Thames & Hudson, London, 1992)

Gogh, Vincent van, *The Letters of Vincent van Gogh* (Penguin Classics, London, 1997)

Gombrich, Ernst, *Gombrich on the Renaissance: Vol. 2: Symbolic Images* (Phaidon, London, 1994)

Hall, James, *Hall's Dictionary of Subjects and Symbols in Art* (Routledge, London, 2014)

—*Hall's Illustrated Dictionary of Symbols in Eastern and Western Art* (Routledge, London, 1997)

Jean, Georges, *Signs, Symbols and Ciphers: Decoding the Message* (Thames & Hudson, London, 2004)

Jung, C. G., *Man and His Symbols* (Dell Publishing Co., New York, 1968)

Morris, Desmond, *Postures: Body Language in Art* (Thames & Hudson, London, 2019)

Panofsky, Erwin, *Studies in Iconology: Humanistic Themes in the Art of the Renaissance* (Westview Press, Boulder, CO, 1972)

Ronnberg, Ami (ed.), *The Book of Symbols – Reflections on Archetypal Images* (Taschen, Berlin, 2010)

Shepherd, Rowena and Rupert, *1000 Symbols: What Shapes Mean in Art and Myths* (Thames & Hudson, London, 2002)

INDEX

Main entries are in **bold**,
illustrations are in *italics*.

Adams, Norman 21
Agar, Eileen 139
alchemy 27, 158, 167
Alexander the Great 102
Alexander, Jane 98–9, *99*
Ali, Qasim ibn 106–8, *107*
angel 16, 44, 124, **130–33**
Angelico, Fra 73
Aphrodite, *see* Venus
Ashoka 95
Ashurbanipal 95, 140
Athanadoros, Hagesandros and Polydoros of Rhodes 101
Aurelius, Marcus 102

Bacon, Mary Anne 57
Banksy 65
Basquiat, Jean-Michel 155
Beccafumi, Domenico 79
Beckmann, Max 157
Beethoven, Ludwig van 96
Bellini, Giovanni *36*, 50, 52, *52–3*
Bembo, Bernardo 43
Benci, Ginevra de' 43
Bermejo, Bartolomé 152, *153*
Bernini, Gian Lorenzo 43
birth 10, 12, 32, 44, 46, 48, 92, 106, *138*, 139
Blake, William 23, 108–9, *109*
blood 12, **124–7**, 145
Böcklin, Arnold 41
Bonaparte, Napoleon 66, 74, 102–3, 103, 119, 145
Bosch, Hieronymus 113
Botticelli, Sandro 16, *18–19*, 21, 50, 119, 138, 139
Botticini, Francesco 132
Bouts, Aelbert (workshop of) 144–5, *144*
bow and arrow **140–41**
Breton, André 27
Bronzino, Agnolo 140–41, *141*

Brown, Ford Madox 117
Burne-Jones, Sir Edward 108, 157
Buddha 16, 46, 48, 72, 95, *116*, 117, *118*, 119, *122*, 123, 129, *134*, 135

Campin, Robert 15, 44–5, *45*
Canova, Antonio 43
Caravaggio 51, 101, 117, *117*, 126, 139, 165
carnation **38–9**
Casas, R. 100–1, *101*
cat **82–5**, 88
Chantelou, Paul Fréart de 128
Charles I, king of England 58, 59
Chitarman 132–3, *133*
Christ, *see* Jesus
Cibber, Caius Gabriel 74–5, *75*
cloud **16–19**, 20, 22, 106
Conner, Lois 48
Constable, John 17
Correggio, Antonio da 17
Cosimo, Piero di 90
Cossa, Francesco del 129
Craig-Martin, Michael 12
Cranach the Elder, Lucas 101
crane 70, 76, **78–9**, 86
Crivelli, Carlo 73
crown 24, **142–5**
Cummins, Paul and Piper, Tom 57
Cupid 79, 82, 140, 141, *141*, 162
cypress **40–41**, 74

Dalí, Salvador 161
Darwin, Charles 98
Das, Kesu 77
David, Jacques-Louis 69, 102–3, *103*, 119, 145
death 7, 12, 23, 32, 39, 40, 48, 50, 56, 57, 65, 69, 70, 72, 87, 88, 97, 100, 112, *113*, 114, 115, 126, 158, 169
deer/stag **86–7**
Delvaux, Paul 113
Dinteville, Jean de 144
dog **88–91**

Donatello 155
Douglas, Aaron *136*, 156–157, *157*
dove 20, 24, 51, **64–5**, 70
dragon 16, 29, 74, **106–9**
Durán, Diego 10
Dürer, Albrecht 95, 151, 158–9, *159*
Dyck, Sir Anthony van 58–9, *59*, 90, 145, 147

eagle 20, 65, **66–9**, 70, 72
Eakins, Thomas 126
El Greco 64
Eliasson, Olafur 30, *31*
Ernst, Max *26*, 26–7, 58
Eros, *see* Cupid
Eyck, Jan van 50, 68, 165
eye **128–9**

falcon 20, 65, 70, **76–7**
fame 156
fertility 10, 23, 50, 53, 65, 72, 92, 100
fire 12, 29, **32–5**
fish **92–3**
foot 46, **116–7**
Fosse, Charles de la 60
Francis I, king of France 140
Freud, Sigmund, 27

Gan, Han 104–5, *105*
Gaozu 106
Gentileschi, Artemisia 146–8, *146*, *147*, 155
gesture 118, **122–3**, 145
Ghirlandaio, Domenico 82
Gibbons, Grinling 53
Gillray, James 74
Giorgione 23
Giotto 35, 132
Gogh, Vincent van 40–41, *40*, 60
Goltzius, Hendrick 85
Gormley, Antony 132
Goya, Francisco de 27, 39, 71
grapevine 50, 51, **52–5**
Gu, Gong 93
Guerrilla Girls 98

173

PICTURE ACKNOWLEDGEMENTS

a above **l** left **r** right **b** below

11 National Museum of Anthropology, Mexico City; **13** Photo Kira Perov. © Bill Viola Studio; **14** Metropolitan Museum of Art, New York, NY. Rogers Fund, 1914; **17l, 17r** Metropolitan Museum of Art, New York, NY. Gift of Bashford Dean, 1914; **18–19** Uffizi Gallery, Florence. Photo Scala, Florence. Courtesy of the Ministero Beni e Att. Culturali e del Turismo; **20** Royal Academy of Arts, London. Photographer John Hammond; **22l, 22r** Metropolitan Museum of Art, New York, NY. Purchase, The Michael C. Rockefeller Memorial Collection, Bequest of Nelson A. Rockefeller and Gifts of Nelson A. Rockefeller, Nathan Cummings, S. L. M. Barlow, Meredith Howland, and Captain Henry Erben, by exchange and funds from various donors, 1980; **23** Photo John Cliett, courtesy Dia Art Foundation, New York, NY. © The Estate of Walter de Maria; **25** National Gallery of Art, Washington, DC, Samuel H. Kress Collection; **26** Tate, London. Ernst © ADAGP, Paris and DACS, London 2020; **28, 29** Philadelphia Museum of Art, Purchased with Museum funds, 1951-29-7; **31** Photo Andrew Dunkley & Marcus Leith. Courtesy of the artist; neugerriemschneider, Berlin; Tanya Bonakdar Gallery, New York, NY/Los Angeles, CA. © 2003 Olafur Eliasson; **33** Freer Art Gallery, Smithsonian Museum, Washington, DC; **34** Private Collection, San Francisco. Photo Atelier Anselm Kiefer. © Anselm Kiefer; **38, 39** The National Gallery, London/Scala, Florence; **40** Museum of Modern Art, New York, NY/Scala, Florence; **41** Tokyo National Museum; **42l, cr, br** Kunsthistorisches Museum, Vienna; 43 National Gallery of Art, Washington, DC, Alisa Mellon Bruce Fund; **45** Metropolitan Museum of Art, New York, NY. The Cloisters Collection, 1956; **47** Egyptian Museum, Cairo; **49** Metropolitan Museum of Art, New York, NY. Purchase, Fletcher Fund and Joseph E. Hotung and Danielle Rosenberg Gifts, 1989; **51** Tate, London; **52** Frick Collection, New York, NY/Bridgeman Images; **54–5** Image courtesy Stephen Friedman Gallery. Photo Stephen White. © Yinka Shonibare CBE. All Rights Reserved, DACS/Artimage 2020; **56** Tate, London; **59** Private Collection/Bridgeman Images; **61** Tate, London. Tanning © ADAGP, Paris and DACS, London 2020; **64** Museo Nacional del Prado, Madrid. Photo MNP/Scala, Florence; **65** Private collection/Bridgeman Images. © Succession Picasso/DACS, London 2020; **67** Courtesy of Rhona Hoffman Gallery. © 2020 Kehinde Wiley; **68** National Gallery, London; **70** Calouste Gulbenkian Museum/Scala, Florence; **71** Metropolitan Museum of Art, New York, NY. The Michael C. Rockefeller Memorial Collection, Bequest of Nelson A. Rockefeller, 1979; **72** Metropolitan Museum of Art, New York, NY. Purchase, Mary and James G. Wallach Foundation Gift, 2015; **73** Louvre, Paris. Photo Josse/Bridgeman Images; **75** Terence Waeland/Alamy; **76** Los Angeles County Museum of Art. From the Nasli and Alice Heeramaneck Collection, Museum Associates Purchase; **77** Metropolitan Museum of Art, New York, NY. Purchase, Rogers Fund and Henry Walters Gift, 1916; **78** Metropolitan Museum of Art, Purchase, Friends of Asian Art Gifts, 2015; **83** Tate, London; **84** Metropolitan Museum of Art, Harris Brisbane Dick Fund, 1956; **86** Hosomi Minoru, Osaka; **87** Metropolitan Museum of Art, New York, NY. Edward Elliott Family Collection, Purchase, The Dillon Fund Gift, 1982; **89** National Gallery, London/Scala, Florence; **91** Adam Eastland/Alamy; **93** Metropolitan Museum of Art, New York, NY. Purchase, Joseph Pulitzer Bequest, 1933; **94** Sarnath Museum, Uttar Pradesh, India/Bridgeman Images; **96–7** akg-images/Erich Lessing; **99** Castle of Good Hope, Cape Town. © Jane Alexander/DALRO/DACS 2020; **100** The Trustees of the British Museum, London; **101** Wellcome Collection, London; **103** Kunsthistorisches Museum, Vienna; **105** Metropolitan Museum of Art, New York, NY. Purchase, The Dillon Fund Gift, 1977; **107** Metropolitan Museum of Art, New York, NY. Gift of Arthur A. Houghton Jr, 1970; **109** Brooklyn Museum of Art, New York, NY/Bridgeman Images; **112** Victoria and Albert Museum, London; **113l, 113r** Collection of Daniel Filipacchi, Paris. © Banco de México Diego Rivera Frida Kahlo Museums Trust, Mexico, D.F./DACS 2020; **114** National Gallery, London; **115** Metropolitan Museum of Art, New York, NY. Purchase, Anonymous Gift and Rogers Fund, 1989; **116** Yale University Art Gallery. Gift of the Rubin-Ladd Foundation under the bequest of Ester R. Portnow; **117** Church of Sant'Agostino, Rome. Photo Scala, Florence; 118 Metropolitan Museum of Art, New York, NY. Purchase, The Annenberg Foundation Gift, 1992; **120–21** Courtesy the artist, Paragon l Contemporary Editions Ltd and Victoria Miro, London/Venice. © Grayson Perry; **122l** Cleveland Museum of Art. Gift of Morris and Eleanor Everett in memory of Flora Morris Everett 1972.43; **122r** Rijksmuseum, Amsterdam. On loan from the Asian Art Society in The Netherlands (purchase J. G. Figgess, Tokyo, 1960); **123** National Gallery of Art, Washington, DC, Samuel H. Kress Collection; **125** Image courtesy and copyright of Marc Quinn studio; **127** The Trustees of the British Museum, London; **128** Photo Musée du Louvre, Dist. RMN-Grand Palais/Angèle Dequierl; **129** The Trustees of the British Museum, London; **131** Photo © Luisa Ricciarini/Bridgeman Images; **133** Metropolitan Museum of Art, New York, NY. Purchase, Rogers Fund and The Kevorkian Foundation Gift, 1955; **134** Metropolitan Museum of Art, New York, NY. Rogers Fund, 1938; **138** Azoor Travel Photo/Alamy; **139** Los Angeles County Museum of Art, Gift of Mr. and Mrs. Harry Lenart; **140** British Museum, London; **141** National Gallery, London; **143** Kimbell Art Museum, Fort Worth, Texas/Bridgeman Images; **144** Metropolitan Museum of Art, New York, NY. The Friedsam Collection, Bequest of Michael Friedsam, 1931; **146, 147** Royal Collection Trust, London; **149** Metropolitan Museum of Art, New York, NY. Gift of Russell Sage, 1910; **150** National Gallery of Art, Washington, DC, Widener Collection 1942.9.97; **153** National Gallery, London; **154–5** Museum of Modern Art, New York, NY. © Kara Walker, courtesy Sikkema Jenkins & Co., New York, NY; **157** National Gallery of Art, Washington. Patrons' Permanent Fund, The Avalon Fund. © Heirs of Aaron Douglas/VAGA at ARS, NY and DACS, London 2020; **159** National Gallery of Art, Washington, DC, Gift of R. Horace Gallatin, 1949.1.17; **160** Private Collection. Höch © DACS 2020; **163** National Gallery, London; **164** Trustees of the British Museum, London

-

For Orla and George

-

First published in the
United Kingdom in 2020 by
Thames & Hudson Ltd, 181A High
Holborn, London WC1V 7QX

First published in the United
States of America in 2020 by
Thames & Hudson Inc., 500 Fifth
Avenue, New York, New York 10110

Design by April
Edited by Caroline Brooke Johnson

British Library Cataloguing-in-
Publication Data
A catalogue record for this book is
available from the British Library.

Library of Congress Control
Number 2020932463

ISBN 978-0-500-29574-8

Printed and bound in China by
Toppan Leefung Printing Ltd

Be the first to know about
our new releases,
exclusive content and
author events by visiting
thamesandhudson.com
thamesandhudsonusa.com
thamesandhudson.com.au

Front cover: Lucas Cranach the Elder, *Adam and Eve*, 1526 (detail), oil on panel, 117 x 80 cm (46⅛ x 31½ in.). The Courtauld Gallery, London

Title page: Artist unknown, *Prince with a Falcon*, c.1600–5 (detail of page 76). Los Angeles County Museum of Art, Los Angeles, CA

Chapter openers: page 8 Anselm Kiefer, *Mann im Wald* (*Man in the Forest*), 1971 (detail of page 34). Private collection, San Francisco, CA; **page 36** Giovanni Bellini, *St Francis in Ecstasy*, c.1476–8 (detail of page 52). Frick Collection, New York, NY; **page 62** Imazu Tatsuyuki, *Peacocks and Cherry Tree*, c.1925 (detail of page 72). Metropolitan Museum of Art, New York, NY; **page 80** Gustav Klimt, *Beethoven Frieze*, 1902 (detail of page 96). Secession Building, Vienna; **page 110** Unknown artist, *Chinnamastā*, 19th century (detail of page 127). British Museum, London; **page 135** Aaron Douglas, *The Judgement Day*, 1939 (detail of page 156). National Gallery, Washington, DC

Quotations: page 9 Samuel Taylor Coleridge, *Biographia Literaria* (Rest Ferner, London, 1817), p.146; **page 37** John Ruskin, *Modern Painters*, Vol. 3 (Smith, Elder & Co., London, 1856), p.101; **page 63** William Blake, *The Marriage of Heaven and Hell* (London, 1793), p.7; **page 81** J. C. Cooper, *An Illustrated Encyclopaedia of Traditional Symbols* (Thames & Hudson, London, 1978); **page 111** Ralph Waldo Emerson, 'The Poet', from *Essays: Second Series* (James Munroe & Co., Boston, 1844), p.21; **page 136** Thomas Carlyle, *Sartor Resartus* (Ginn & Co, Boston, 1897); **page 166** Charles Baudelaire, *Fleurs du mal* (*Flowers of Evil*), translated by Jacques LeClercq (Mt Vernon, NY: Peter Pauper Press, 1958; original ed. Paris 1857)